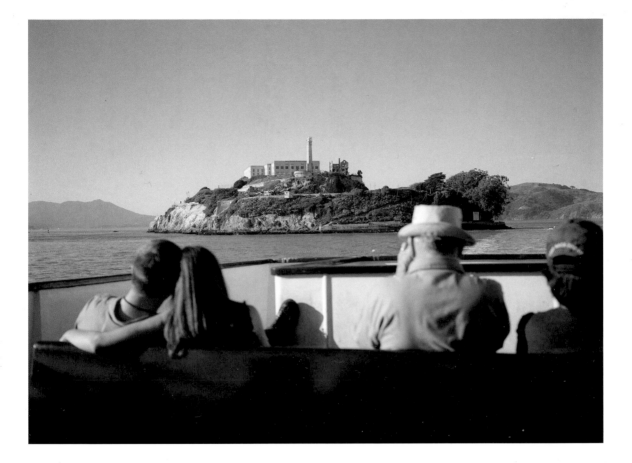

HIDDEN

ALCATRAZ

THE FORTRESS REVEALED

edited by **Steve Fritz and Deborah Roundtree**

Foreword by Peter Coyote Introduction by John Martini Afterword by Thom Sempere

University of California Press
Berkeley Los Angeles London

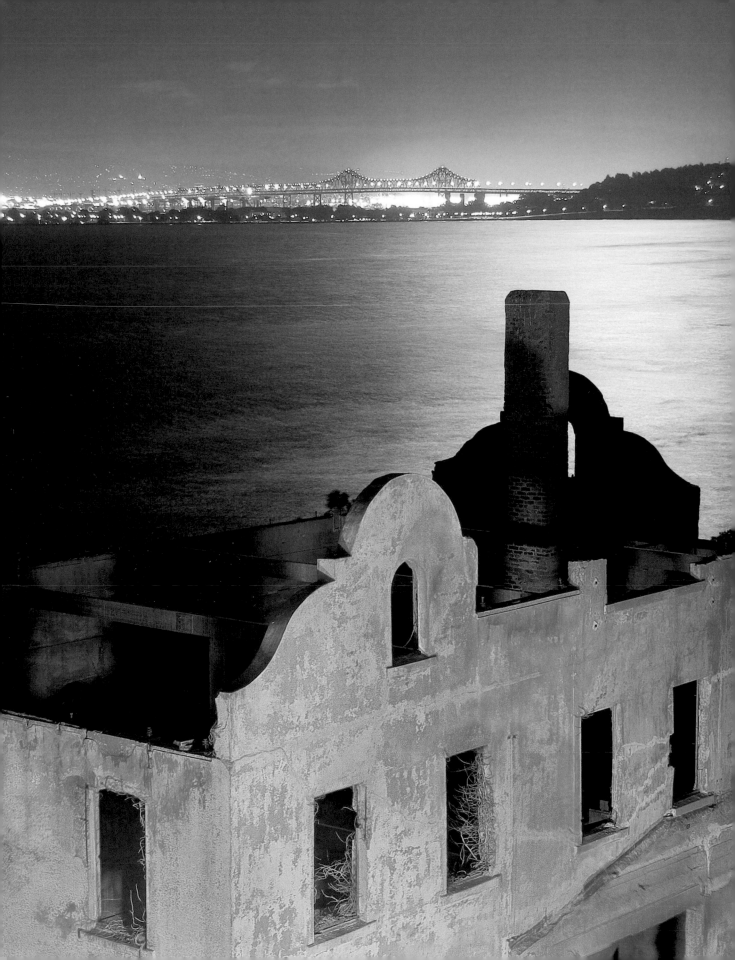

Contents

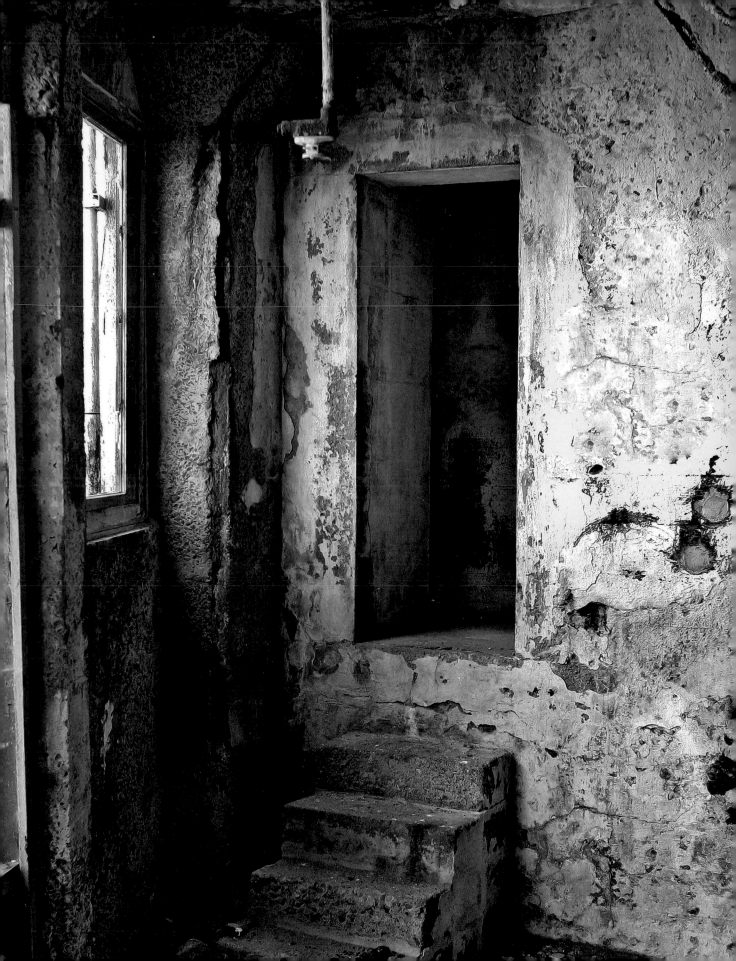

THERE IS REALLY NOTHING TO SAY, which is why photographs are perfect. I prefer the grainy black and whites, which have the same galvanizing power as an old, creased 1940s pornographic playing card I found on the street when I was twelve. "Beauty is in the eye of the beholder," they say, and it is a testament to the elasticity of the human spirit that there are humans who can perceive beauty even here. There are plenty of refined aesthetics in these pages: lichens reclaiming Italianate balustrades, photographs luminous with the Bay Area's unique fog and Mediterranean light. Some photographers manage to frame this original "rocky horror show" within expansive vistas of San Francisco Bay, which somehow tame it.

A prison itself is pornography to me, like slow-motion, aestheticized murder in the movies. It doesn't matter if it's gleaming and spotless as a refrigerator with glass windows looking into the cells, or this archaic ruin reminiscent of Pol Pot's abbatoirs in Cambodia. A prison is, at root, an act of domination and control that cannot be disguised or prettied. Consequently, my favorites in this book, the photos that get the blend of subject and interpretation just right, are of a different sort: the spiral staircase with a ghostly human shadow floating above it, the peeling girder with an empty gurney and shredded gossamer screen. These photos reveal and do not disguise what occurred here and how it felt. They do not soften society's attitude toward the humans it warehoused here. Nothing is leavened with compassion or understanding. Nothing is denied the authorities.

I was there in June of 1971. It was already a ruin, and Native Americans had seized it, justifying their occupation with an old Black Hills treaty of 1868, which appeared to indicate that Indians could reclaim government surplus lands no longer of use to the U.S. The "invasion" had started as something of a gag, but as publicity about it grew, and as it energized Native American communities across the

continent, it began to accrue weight and depth. I had a tipi on the communal land that I lived on not far away in Olema, and sent it out as a gesture of respect and support. My extended family, the Diggers, an anarchistic group that had been feeding and sheltering the hungry in the San Francisco's Haight-Ashbury, possessed a decrepit and decidedly un-shipshape old boat called *The Bare Minimum*. My compadres Captain Freeman House, David Simpson, and Vinnie Rinaldi ran the Coast Guard blockade to deliver food and water to the Indians camped on the Rock. (How that old scow could have evaded even a child's scooter mystifies me today.) From our point of view, the occupation was heroic. Babies were born, and people died there. These young men and women were playing for keeps—as were we—and it was not lost on anyone with a sense of metaphor that a new life was germinating in the soil of this monument to human cruelty.

Before there were humans, there was just this lump of rock dominating the beginning of the San Francisco Bay, the Santa Barbara Channel, near Point Concepción, to the Klamath Mountains in Siskyou County in northern California. Every iota of Alcatraz's weather is generated by the eternal tug of war between the low-pressure zone of the inland East Bay—the vacuum produced by heat rising off sun-warmed earth—locked in a respiratory cycle with the ocean-cooled air attracted by that vacuum. It is inhaled inland every afternoon as the heat rises, and exhaled every evening as the heat dissipates. It is the natural breathing of the Bay, wheezing through the bars and hissing through the old wires.

That fog is in the book too, and it's a favorite. It engulfs the prison as it does the hills, covering them as an irresistible common denominator. It moistens and cools the cypress and camp jays, the redwoods and deer, cloaking everything in damp mystery. It is master here and, for the attentive, it places the human world on notice that our power is limited.

Perhaps that insult to our self-generated grandeur is part of the reason control here is so insistently visible. In the face of nature's daily reminders that our aspirations and delusions amount to so much bird shit on a windshield, perhaps the wardens and guards were moved to exert evidence of control over and above what would appear to be required on a desolate island in the midst of freezing, shark-infested waters.

Don't let my pretty theory blunt the fact that the authorities had plenty of justification for keeping the lid on out here. They didn't send pickpockets to Alcatraz or petty thieves. Basil Banghart, who helped Frank Tuohy escape from Joliet, killing several guards in the escape, was here. Machine Gun Kelly's partner, Harvey Bailey, was here, and the authorities suspected but could never prove that he was involved in the Kansas City Union Station Massacre, where gangster Vernon Miller tried to free his pal, Frank "Jelly" Nash, while four policemen were murdered. Al Capone was here, and so was Joseph Cretzer, who led the 1946 "Blast-out," and executed

three guards held hostage, in cold blood. It was a tough time, and the people sent here were the toughest. You can see from the architecture, from the overkill of concrete and tiers, the pipes and gated corridors, that Alcatraz was ready for them.

Considering Alcatraz, my imagination turns again and again from the infernal logic of society and law, and its carnal attractions to cruelty, back to the rock itself, older even than the birds for which it was named. Most people translate Alcatraz as "pelican," and I suppose that suffices. Those staid, archaic, and grave birds are still here, floating between the spans of the Golden Gate Bridge, or settling lightly on the waters. It's not a bad fit.

But in Spain, whose language most early settlers would have been speaking, Alcatraz is translated as "gannet"—a different story altogether. Gannets are large black-and-white sea birds with powerful pointed bills, with heads often a rosy beige fading stylishly into the white and black of their bodies. Their wingspans reach six feet. Diving into the sea from great heights, they achieve speeds of over sixty miles per hour, to catch large fish below the surface.

To survive these dives, they have evolved curious adaptations. They have no external nostrils, for instance, no break in the beak through which water could enter and damage them. Under the skin of their face, and chest, they have air pockets that serve as a kind of natural Bubble Wrap that protects them from the impact of hitting the water at high speeds. Most curiously, their eyes are positioned far enough forward so that, unlike most birds, they see with binocular vision.

I am partial to these birds as a symbol. I suspect that my friend Jack Loeffler, the bird lover and desert rat who introduced me to the book's project manager, would cleave to them, too. It is fitting that Jack returns me to Alcatraz, because in the eyes of some he might be considered a criminal. Jack is the man who—at Ed's request—liberated author Edward Abbey from the Tucson hospital where he was dying and, with three friends, later buried him somewhere in the desert vastness Ed so adored.

Jack's an outlaw in the same sense those Indians were, or my friends and I in the Diggers. We all violated meaningless laws in the service of cruelty and greed, but never transgressed higher laws of decency, respect for life, and honor of creation. None of us approached the threat and menace of the men housed here, and yet we, like them, are men, and capable of anything. Alcatraz is a monument to that side of human nature we prefer to forget. I am happy it is here, and happy, too, to watch it crumble. I enjoy this record of its dissolution, captured by these skilled and observant photographers and, as I stand on the Golden Gate Bridge, my eyes pass over Alcatraz and scan the horizon for gannets. I see none. Perhaps they are nesting in the concrete shards of Alcatraz.

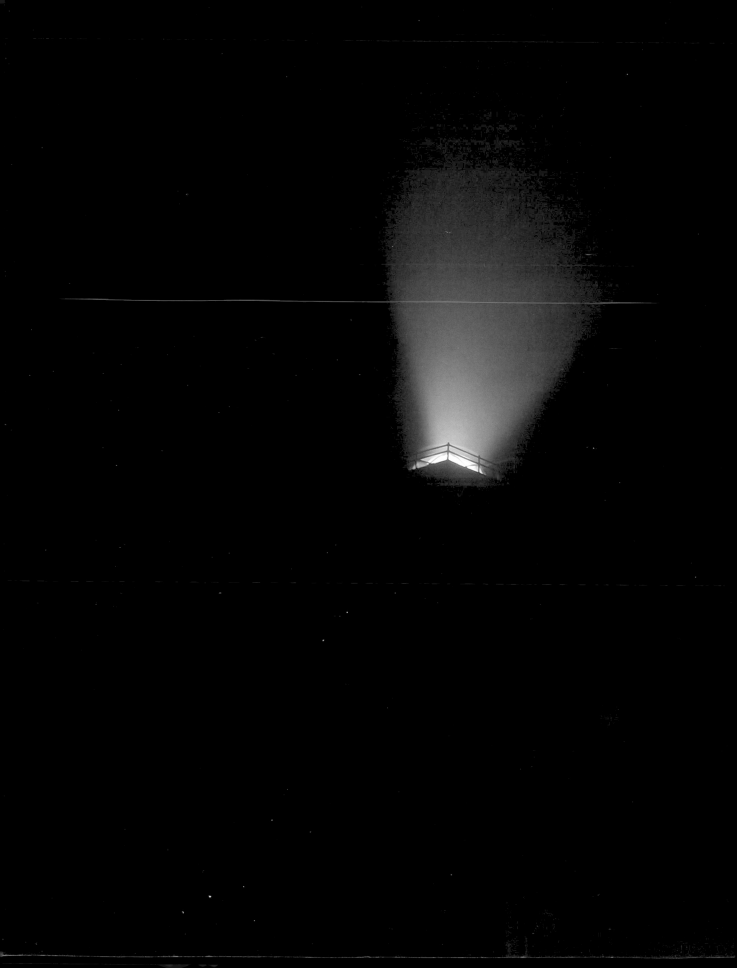

ALCATRAZ'S HISTORY is a very short one, especially if you follow the arguable Western concept that history begins with written narrative.

The local Ohlone and Miwok people left no written record of their thousands of years inhabiting the Bay Area, so the history of San Francisco—and Alcatraz—must begin with the arrival of the first European explorers in 1769. At a time when the thirteen colonies along the Atlantic were beginning to dissolve their bonds with England, a party of Spanish foot soldiers searching for the near-mythical harbor of Monterey Bay overshot their mark and found themselves on a November morning looking at a vast "arm of the sea" extending into the land, a body of water later christened San Francisco Bay.

If these first explorers saw Alcatraz Island, they made no mention of it. The first time the name *Alcatraz* (or something close to it) appeared in a printed record was 1775, when a Spanish navigator prepared the first chart of the bay and applied the name *Isla de Los Alcatraces,* or Island of Sea Birds, to a rockbound island not far from his ship's anchorage at Angel Island. (The local tribes apparently had no name for the barren, waterless island in the bay, at least none that they ever shared with the Spanish.)

Historians generally agree that the island the navigator charted was actually today's Yerba Buena Island, not Alcatraz, which was only shown on his map as a nameless rock. The latter islet would remain nameless until 1826, when a British mapmaker transferred the name *Alcatraces* to it either by mistake or unknown intent, and slightly reworked the name as *Alcatrasses.*

Over the next twenty-odd years, the island (and all of California) changed hands from Spanish to Mexican to U.S. control and, in 1847, an American surveying party first recorded its rocky slopes when the United States became interested in

acquiring the island. However, it wasn't until 1853, during the California Gold Rush, that Alcatraz was first occupied. A construction gang arrived and began the laborious challenge of converting the barren rock into a fortified island. Over the next six years the workers carved out roads, gun batteries, and a plateau for a lighthouse from the deeply sloped hillsides, and tunneled into the rock to create water cisterns and ammunition storage magazines. As a crowning touch, the army's workers built a multistoried citadel atop the highest peak that would serve both as living quarters for the garrison and as a site for a last-ditch stand if the island ever were besieged. It never has been.

The island thus began the first of its three lives, that of a fortress. The U.S. government originally envisioned Alcatraz as a permanent fort in the heart of San Francisco Bay that would deny an attacking enemy fleet the ability to enter the harbor or safely anchor anywhere within cannon range of San Francisco. In December 1859, the fort was officially finished. When the Civil War began sixteen months later, the island fort mounted nearly one-hundred cannon and held a garrison of nearly the same number of soldiers.

Throughout the Civil War years of 1861–1865, the army repeatedly increased the size and number of weapons on the island and the number of soldiers assigned to its batteries. However, it was Alcatraz's nearly inaccessible location that gave rise to its second and much longer role as a military prison. A few military prisoners had been confined on the island from the day it opened, some from the fort's own garrison and some transferred from other army posts. Shortly after the start of the war the United States government realized that the swift, bone-chilling waters surrounding the Rock also made it perfect for locking up special civilian prisoners. When President Abraham Lincoln suspended *habeas corpus* in 1862, many pro-Southern activists and confirmed Secessionists found themselves locked up on Alcatraz without right to counsel or even knowing how long they would be confined on the island. Thus it can be argued that Alcatraz Island was a precursor to the terrorist detention facility at Guantánamo Bay established nearly a century and a half later.

Alcatraz continued its awkward dual role of harbor defense fort and army prison throughout the nineteenth century. Following the Civil War, the number of cannon on the island decreased as its strategic importance waned. Simultaneously, the number of prisoners confined within the island's wood and brick cellblocks increased as the U.S. Army's presence expanded in the West. Over the years, the military prisoners' ranks included deserters, thieves, murderers, arsonists, and every other type of deviant who found his way into America's frontier army.

Occasionally, Native American prisoners also were sent to the island. Some of these, such as members of the Apache and Modoc tribes, had waged war against the U.S. Army, while others had practiced nonviolent resistance to Bureau of Indian Affairs policies in the Southwest. Either way, these warriors served their time on Alcatraz as *de facto* POWs of the Indian Wars.

By the early 1900s the island was definitely obsolete as a fortress and began its second career, as Pacific Branch, U.S. Military Prison. In 1902 more than 400 men were confined there, and the army began making plans to remodel Alcatraz as a purely penal isle. As part of this project, aging buildings and abandoned fortifications were demolished and replaced by state-of-the-art prison cellblocks and support structures. Beneath the modern prison buildings, though, a handful of storerooms originally constructed as part of the 1850s fort were incorporated into the new design. These rooms, officially designated as dungeons, would serve as solitary confinement spaces of near-medieval conditions for many years to come. The overhaul was completed in early 1912, and three years later the fort on Alcatraz officially became known as U.S. Disciplinary Barracks, Alcatraz Island. By this time the prison was confining soldiers from every point west of the Rocky Mountains, a vast geographic area that included Hawaii, Guam, the Philippine Islands, and even outposts in China.

The high tide of Alcatraz's history as a military prison was reached shortly after the end of World War I, when more than 600 convicts were confined in its cellblocks. But by the 1930s, Alcatraz had become a burden to the military. It was expensive to run, it lacked adequate workshops and rehabilitation facilities, and its high visibility in the center of San Francisco Bay had become an embarrassment. The army decided to move out in 1933.

But the island's visibility made it attractive to another government agency, the Department of Justice. The Rock's notorious placement would serve, they believed, as a deterrent when it became home to America's most notorious and incorrigible federal prisoners. So in 1934, the department's Bureau of Prisons remodeled the island as a maximum security/minimum privilege penitentiary for the worst of America's federal convicts. Unlike their soldier predecessors, most of whom had been relatively inexperienced hoodlums, these hardened cons would include the worst bootleggers, gang kingpins, kidnappers, bank robbers, and escape artists in the nation's federal prison system. In this incarnation, the island would also receive yet another name: U.S. Penitentiary, Alcatraz.

This third era lasted twenty-nine short years, from 1934 to 1963. During this period the institution housed more than 1,500 "dangerous and irredeemable-type" convicts with an average population of around 260 men at any given time. Thanks to a nonstop barrage of Hollywood movies and overwrought magazine articles, its reputation far outstripped its relatively small size. For the American public the name "Alcatraz" became synonymous with mad killers and thuggish, club-wielding guards.

It was a bum rap. The island was indeed tough, but the prison also was relatively fair to its inmates, and it fed them well. Many convicts actually appreciated the high security on the island and the large ratio of guards to inmates. It meant assaults and gang violence were less frequent than at other contemporary penitentiaries. In the course of interviewing over a score of men who did time on Alcatraz, I never

met one who liked the place. But they all grudgingly admitted that it was probably the safest place they ever did time.

The worst aspect of Alcatraz as a prison wasn't its brutality, but rather a rigorously enforced lack of privileges and what has been described as the "exquisite torture of routine." Each day was virtually identical to the previous one and the one that would follow, with the only breaks being extra yard time and church services on the weekends. Work was a privilege. So were books, visitors, smoking, hobbies, exercise time, and, for several years, talking. An inmate earned these privileges and others by following the institution's rules. The ultimate privilege was a transfer to another federal prison, generally the one from which a convict originally had come.

USP AZ, as it was known in government shorthand, closed in early 1963, a victim of cost-saving measures instituted by the Department of Justice under the Kennedy administration. The island was getting old and needed millions in repairs just to bring it up to even minimal penal standards. Also, a spate of escape attempts had debunked the island's long-held reputation as being escape-proof. (Three cons had actually disappeared from *inside* their cells, to the extreme chagrin of the Bureau of Prisons.) More importantly, the penitentiary had outlived its original purpose of securely locking away Depression-era desperadoes and Prohibition gang lords. It was simply easier to close the place, the government decided, and replace it with a new institution elsewhere in the country.

On March 21, 1963, the last handful of inmates shuffled off the island's dock and onto a waiting prison launch. Shortly after their departure, the corrections staff and maintenance crews and their families also began to depart Alcatraz. Even the lighthouse was automated; the only residents remaining on the island were a watchman and his family who stayed behind to ensure that the lighthouse and foghorns functioned properly, and to chase away curious yachtsmen.

Alcatraz entered a near-limbo state that lasted until late 1969. During this period, the few visitors who gained permission to visit the island reported that it was a virtual time capsule of the day it closed, and that walking its streets up to the prison was like visiting a postapocalyptic small town inhabited only by sea gulls and cormorants.

In November 1969, several dozen Native American activists swarmed the Alcatraz dock and claimed it as Indian land, citing as justification an 1868 treaty with the Sioux Nation. Their legal argument might have been tenuous, but the resulting publicity and wave of public support that followed thrust the by now nearly forgotten Alcatraz and its occupiers into the public spotlight.

Calling themselves the "Indians of All Tribes," the occupiers soon numbered several hundred men, women, and children. A school and medical dispensary were established, a tribal council formed, press conferences held and, with ironic wit, a branch office of the "Bureau of White Affairs" was opened.

The whole event couldn't hold itself together, though. A lack of supplies, political infighting, drug use, and tribal frictions soon caused an exodus. Some folks stuck it out to the bitter end, although one occupier later stated that life on Alcatraz during the waning months was like something out of *Lord of the Flies.* After nineteen months, U.S. marshals arrived quietly one morning in June 1971 and removed the last holdouts—some fifteen people—who were taken to the mainland, issued citations, and released.

The U. S. government announced new plans for Alcatraz Island in late 1972, when Congress created a new national park called the Golden Gate National Recreation Area. The expansive park would include thousands of acres in and around San Francisco, and Alcatraz would become a key feature. The island's scenic location and history as a lighthouse and military fort were seen at that time as the primary reasons for its preservation.

A year later, in October 1973, the island was opened to the public for the first time with great fanfare and media coverage not seen since the first days of the Indian occupation. Since that first tour more than thirty-five years ago the island has become increasingly popular with visitors, owing in part to Hollywood's continued movie and television productions about the island, and in part because of the increasingly professional interpretation of the island, which now features an audio tour comprised of oral histories with island residents. At the time of this writing, the island averages about 1.4 million visitors annually. It could probably handle more, but the Park Service, concerned about the quality of visitors' experiences, calculates that saturation levels have been reached.

Along with the increasing number of visitors, there has been a growing realization that Alcatraz's history and importance extend beyond the lighthouse and military fort stories. The National Park Service has come to realize the island has extensive significance in its role as America's first "supermax" prison, its media-created public image, and its resulting place in modern American culture. The significance to Native Americans also has continued to increase, and the Alcatraz Occupation is recognized as the site of the rebirth of the Indian Rights movement in the United States. Finally, the island has been documented as a major roosting and nesting area for a dizzying number of sea birds including Western gulls, Brandt's cormorants, pelagic cormorants, and black-crowned night herons.

This is Alcatraz today: a mix of crumbling infrastructure, Hollywood-bloated lore, sacred native lands, the detritus of human misery, a burgeoning wildlife population, and a nearly overlooked—and literally buried—legacy as a fort and military prison. It's a history that people from all over the world come to explore and experience, and to photograph. Upon reaching the island, all arriving visitors are met by a park ranger and receive the same resonating greeting: Welcome to Alcatraz.

HIDDEN

ALCATRAZ

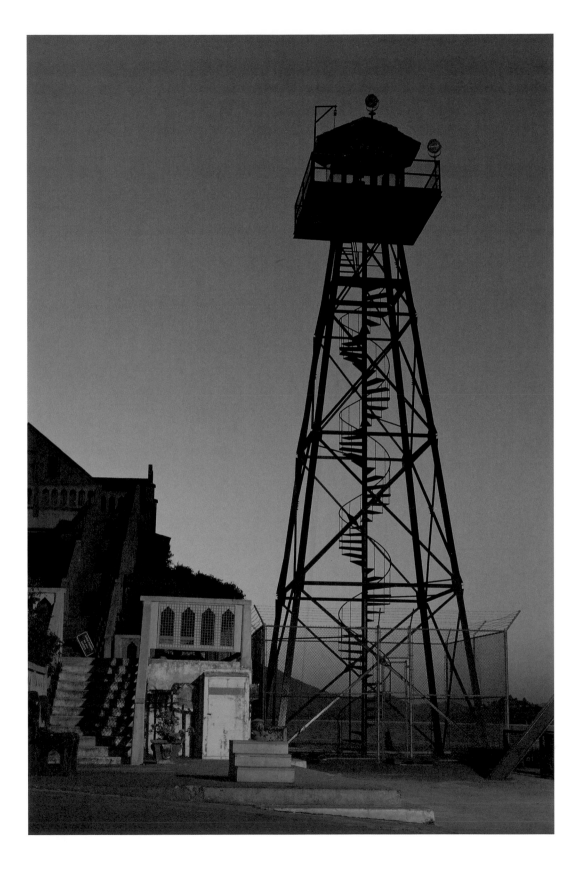

THOM SEMPERE OBSERVATION TOWER FROM THE DOCK

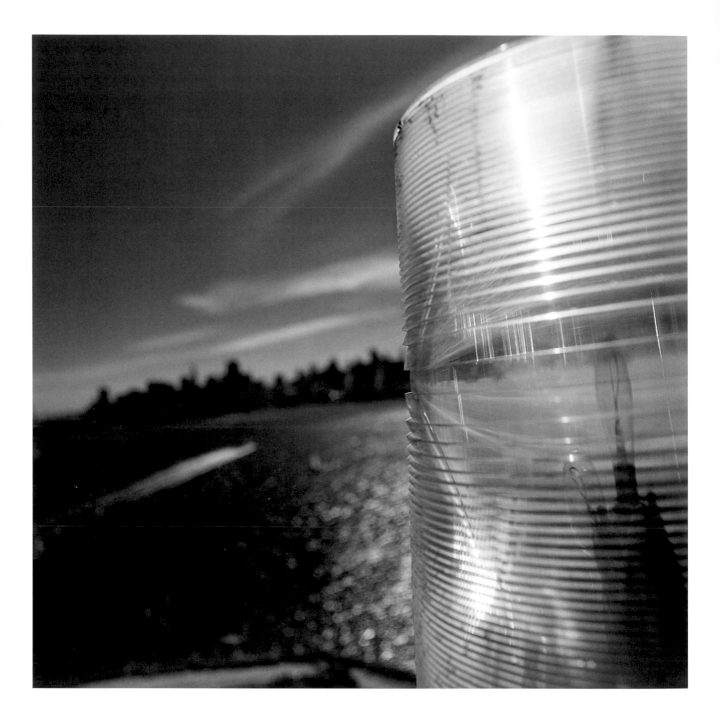

HENRIK KAM LIGHTHOUSE BEACON

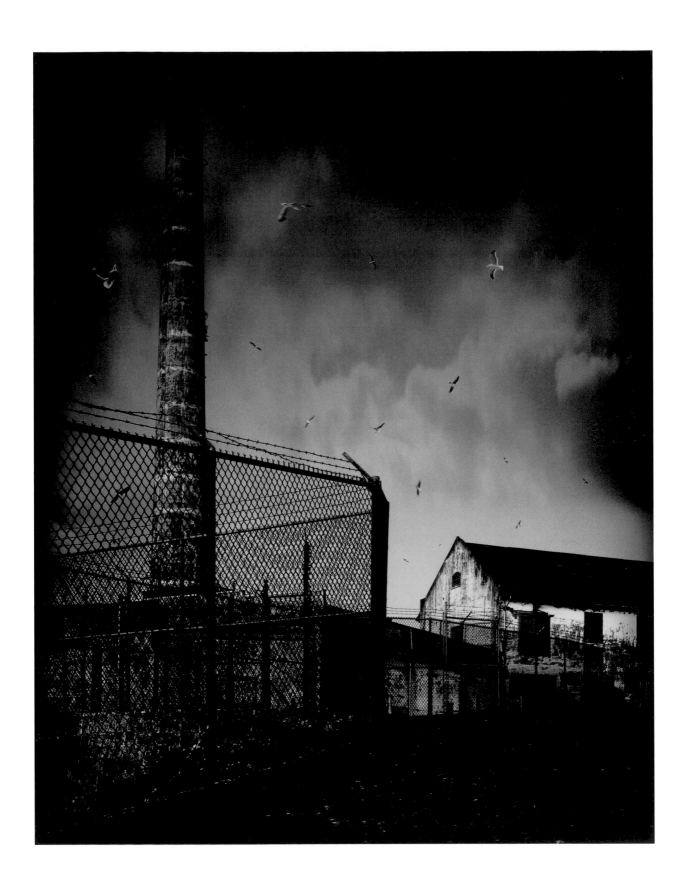

MICHAL VENERA UNTITLED

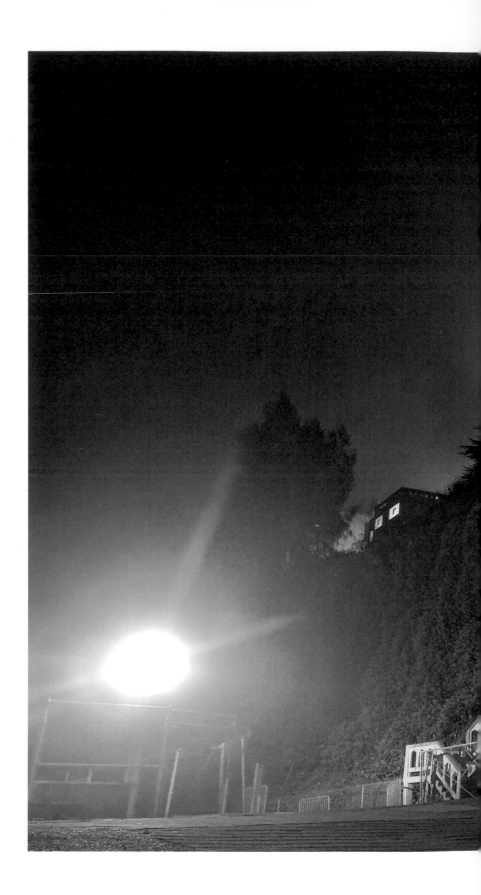

THOM SEMPERE LATE NIGHT FOG, LOOKING TOWARD THE CELLBLOCK

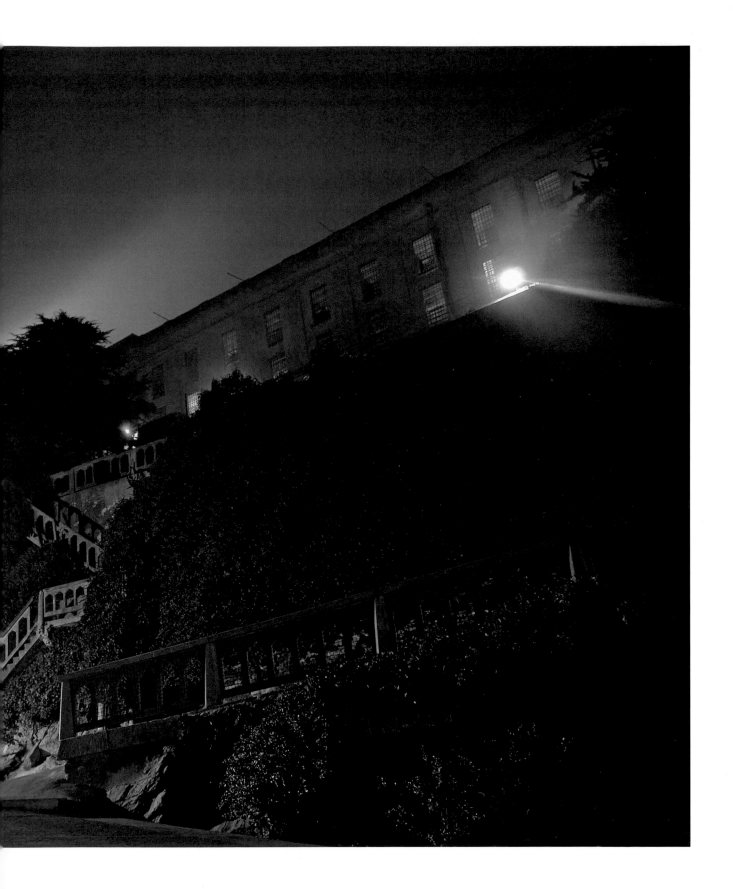

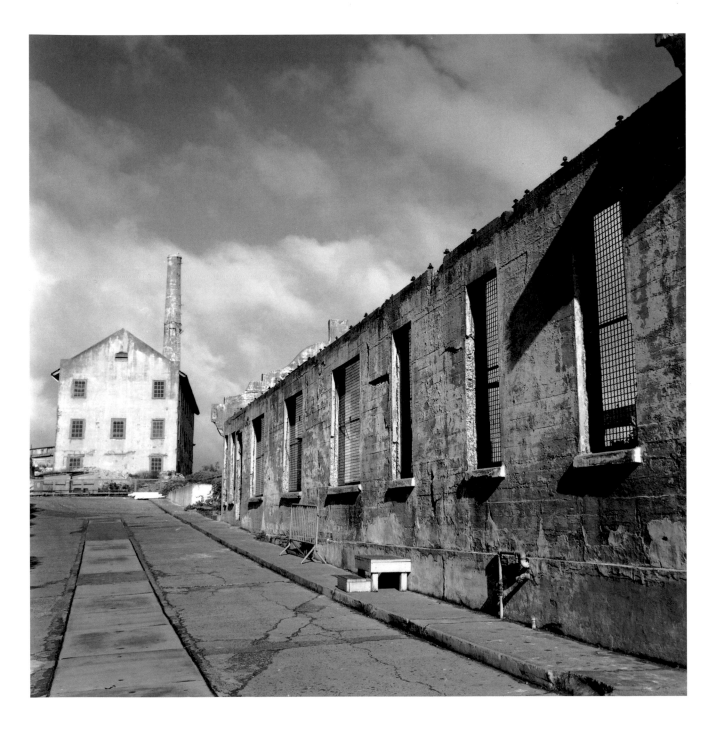

ANTON ORLOV STREET VIEW WITH CLOUDS

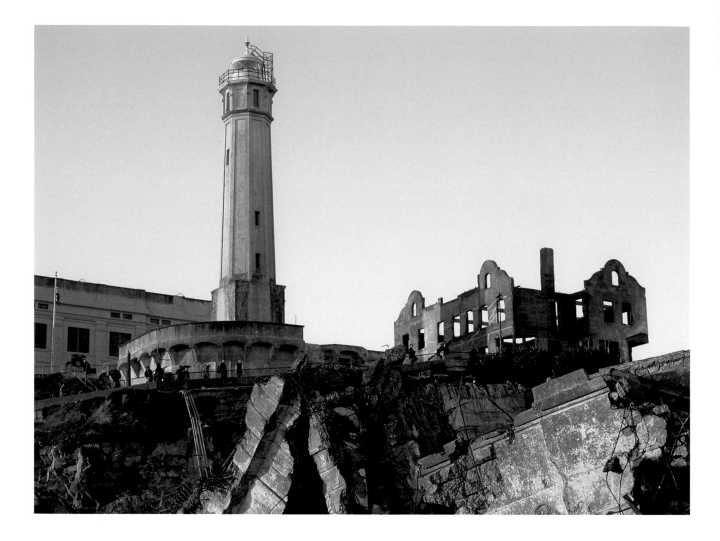

STEVE FRITZ LIGHTHOUSE AND WARDEN'S HOUSE AT SUNSET

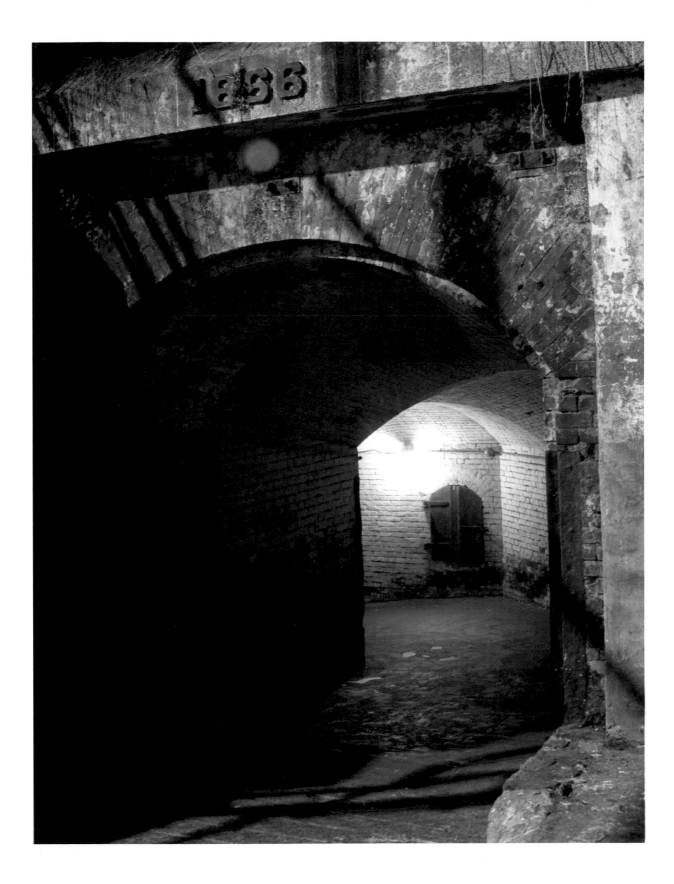

ROBERT RENNEKER 1866 TUNNEL

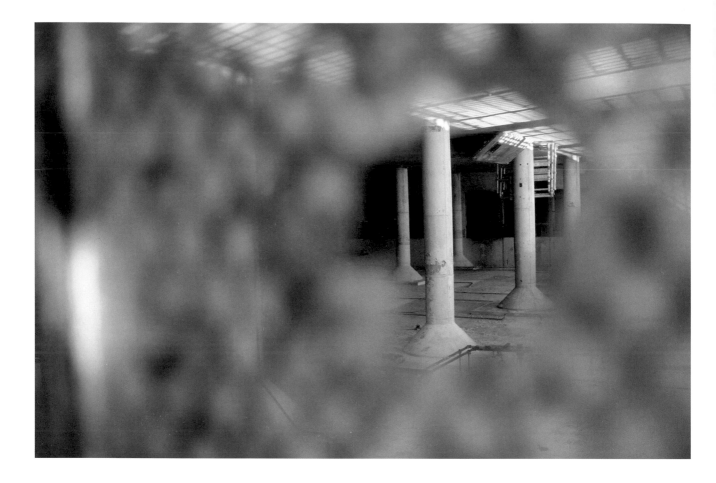

PATTY FELKNER LEEWAY, ALCATRAZ

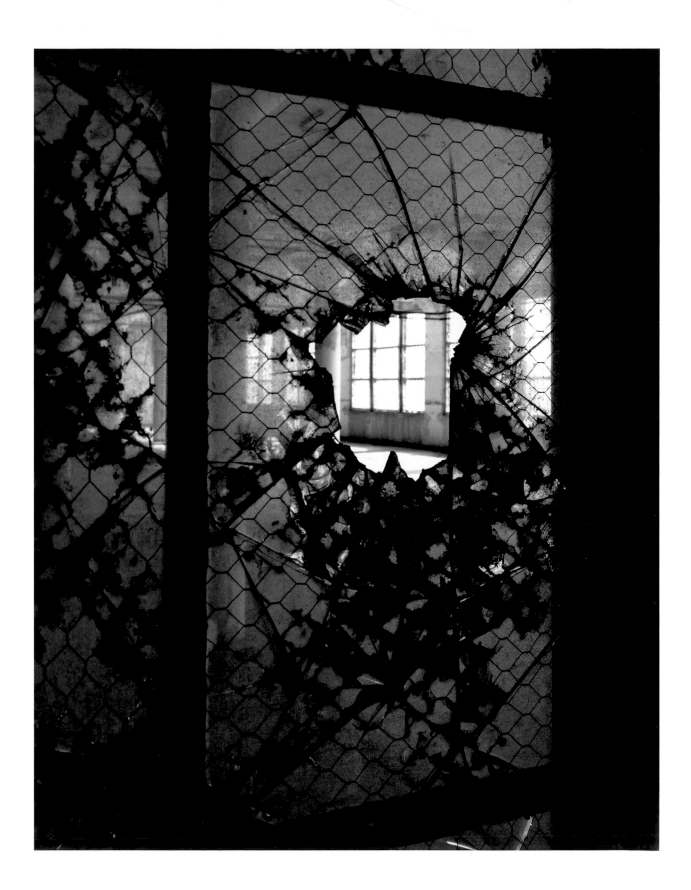

MICHAL VENERA UNTITLED

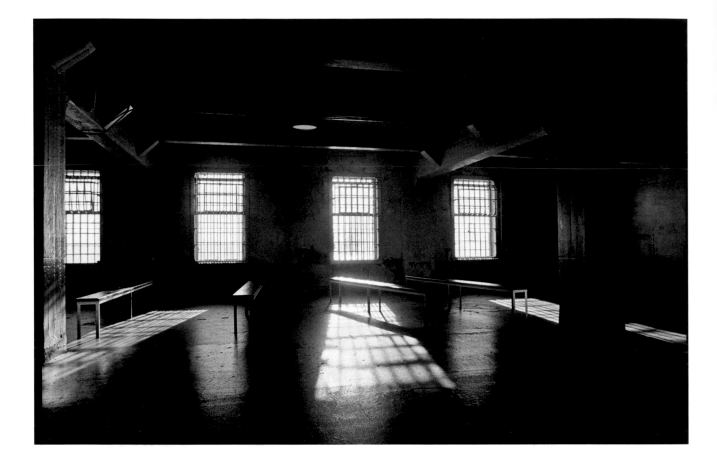

NADINE DEFRANOUX THE REFECTORY

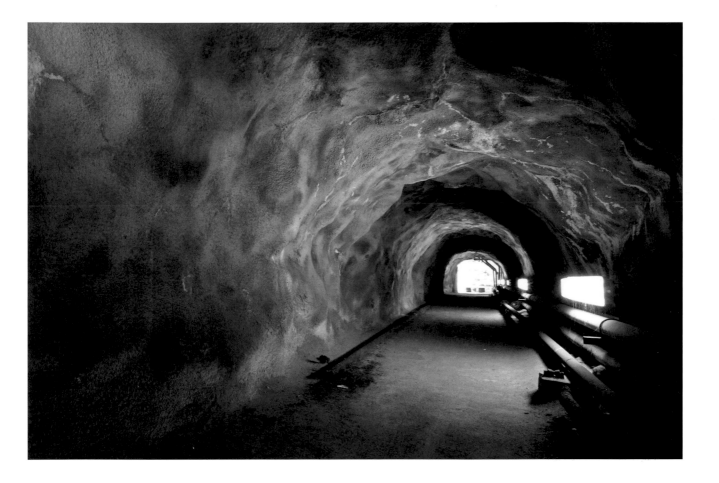

DAN KATZMAN THE GUARDS' TUNNEL TO THE PRISON LAUNDRY

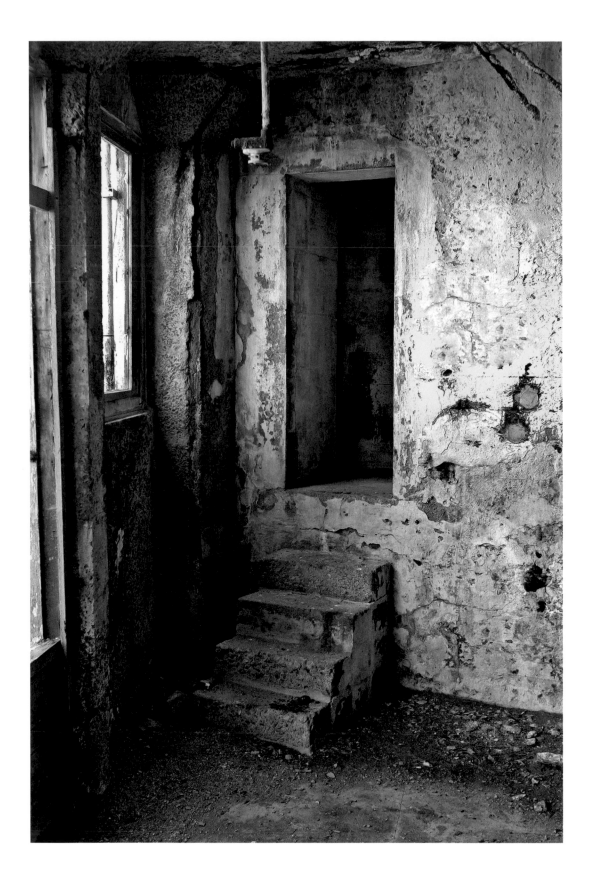

RALPH WILSON STAIRWAY TO NOWHERE

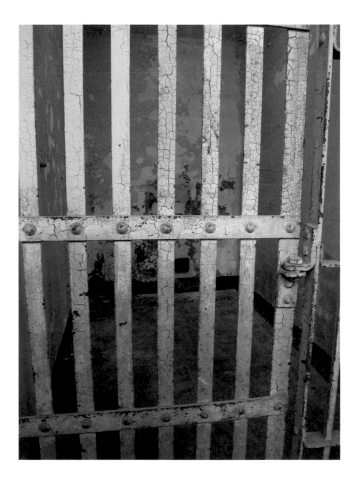

THOM SEMPERE CELL, FROM THE GOOD SIDE

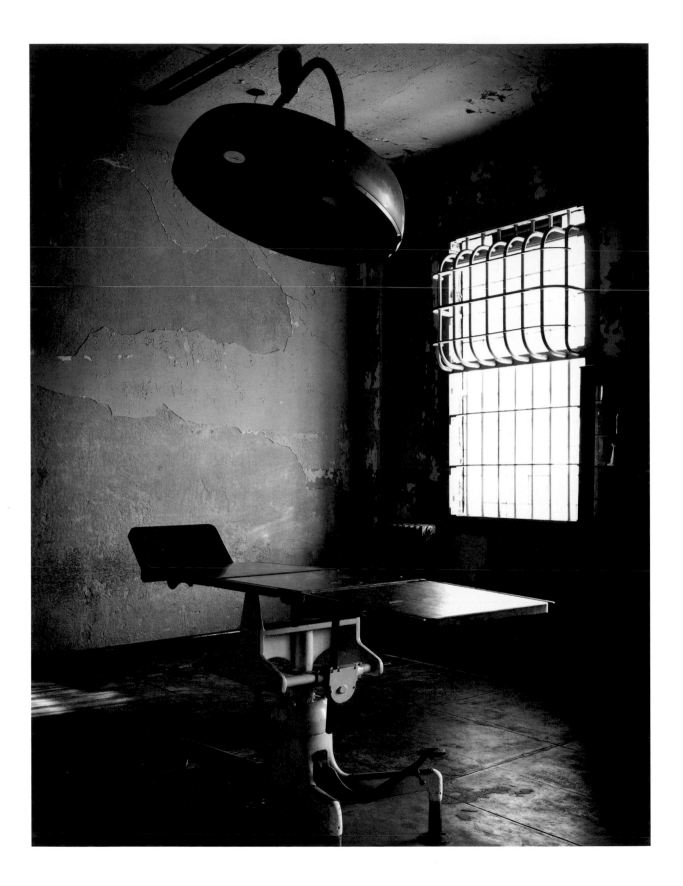

MICHAL VENERA UNTITLED

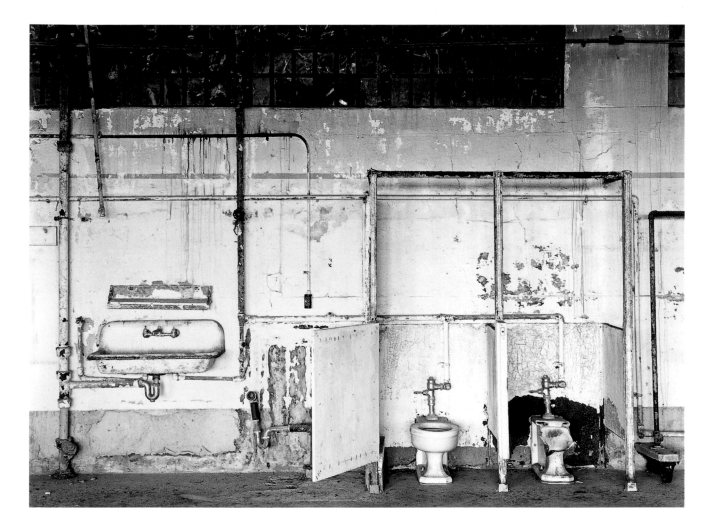

ANTON ORLOV IN THE LAUNDRY ROOM

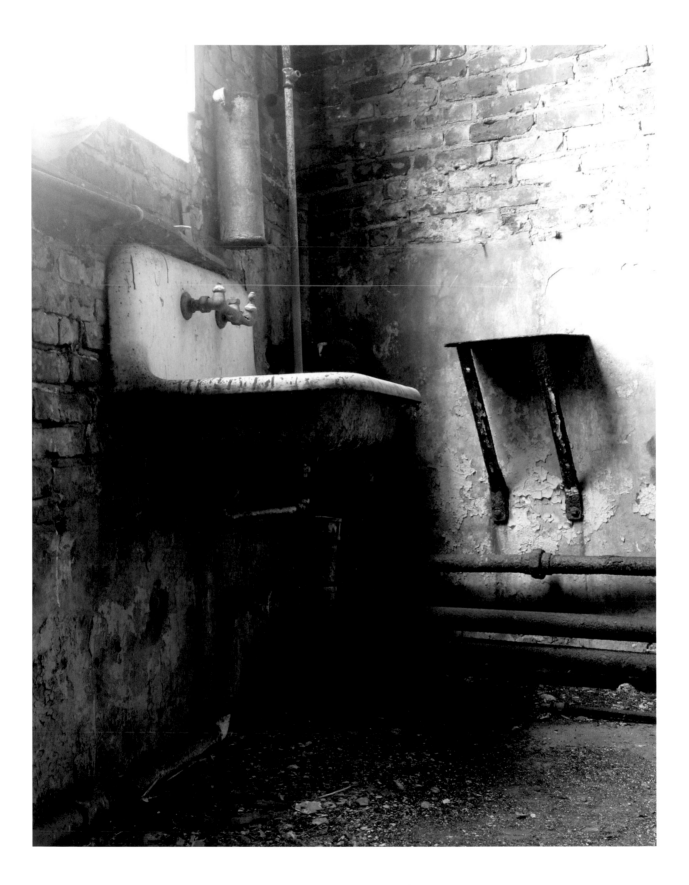

ALICIA WILLIAMS MORNING LIGHT

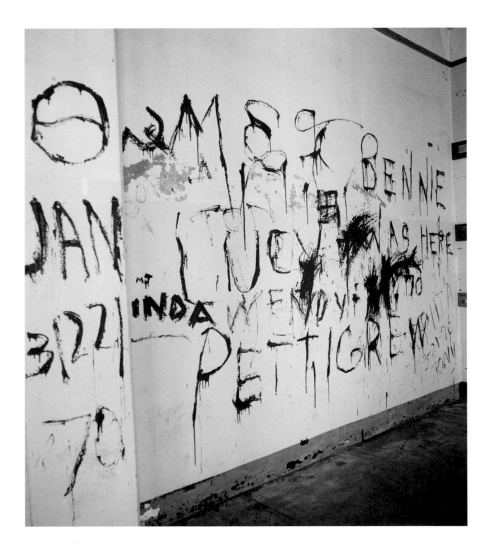

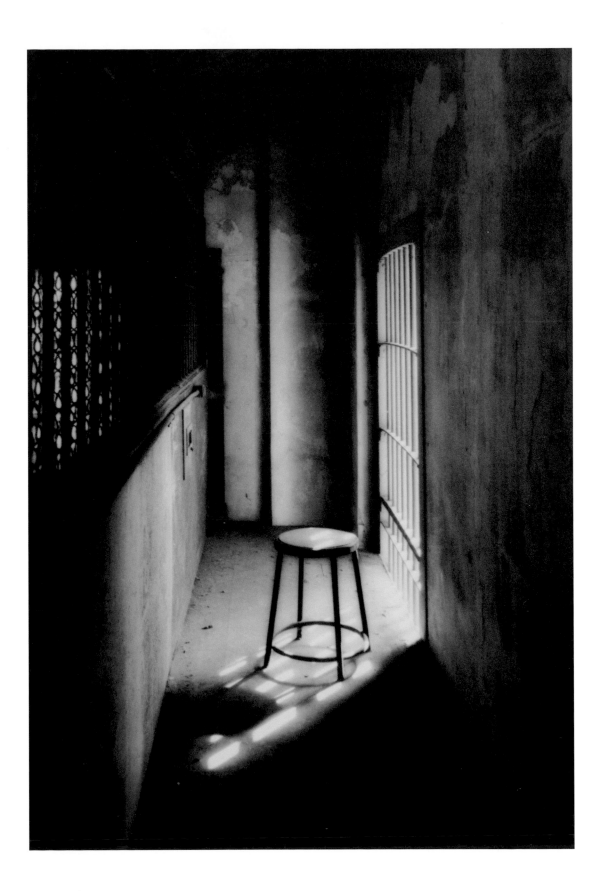

RICHARD KETTLES GUARD WALK STOOL IN THE SUN

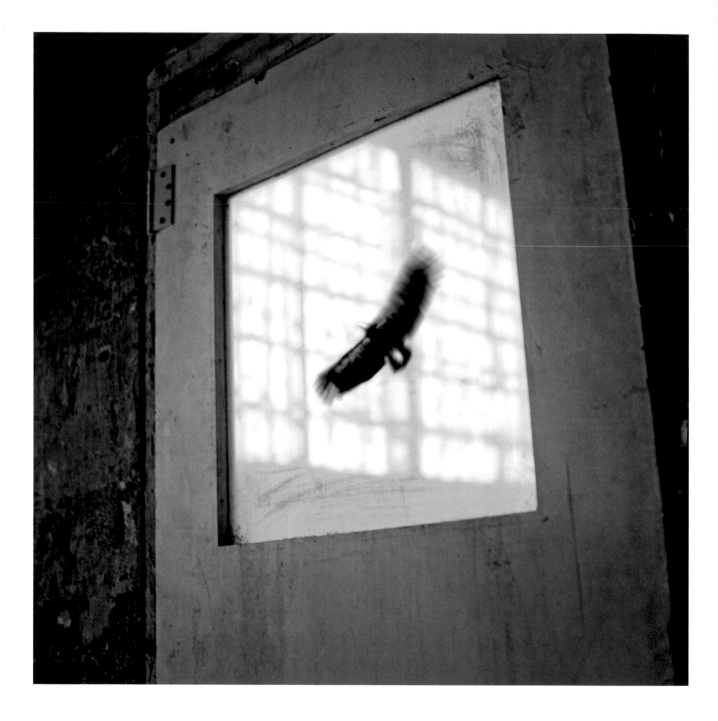

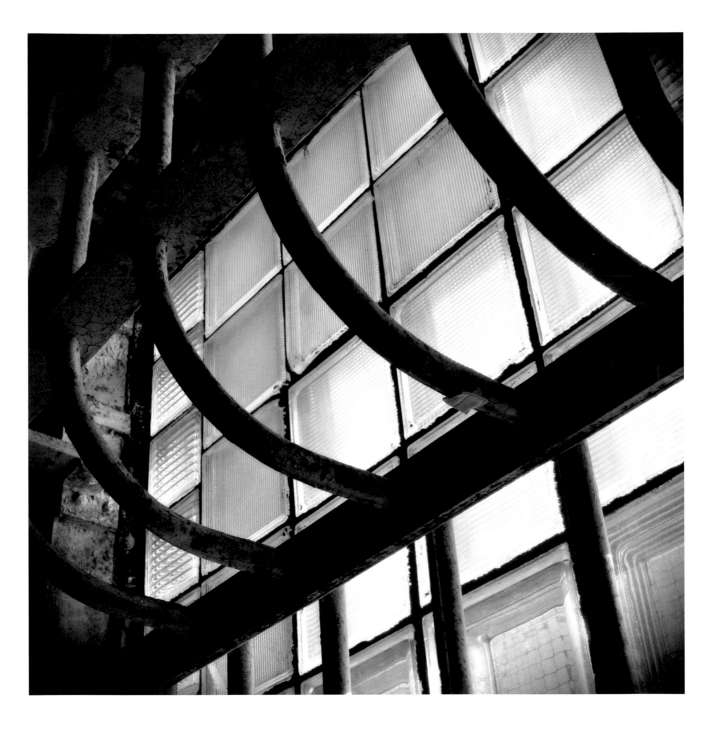

LINDA HANSON BARS, A RANDOM CORRIDOR, NO WAY OUT; EVEN THE LIGHT IS BLOCKED

KYLE PATTERSON INSIDE THE HOLE AT ALCATRAZ

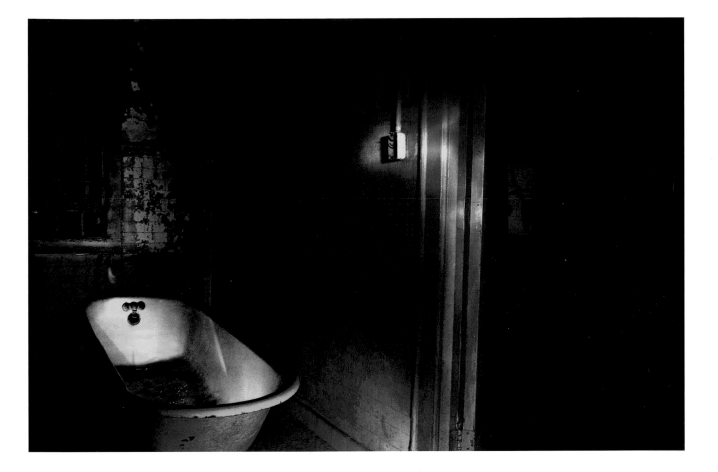

JASON SHELDRICK HYDROTHERAPY 3:00 AM

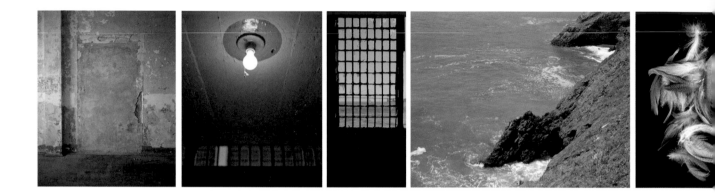

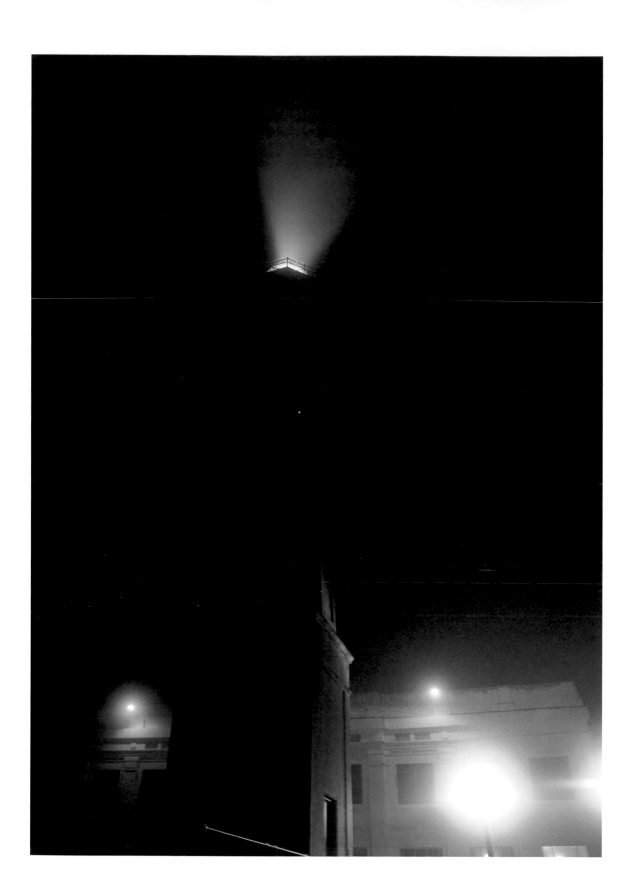

STEVE VANCE ALCATRAZ LIGHTHOUSE IN NIGHT FOG

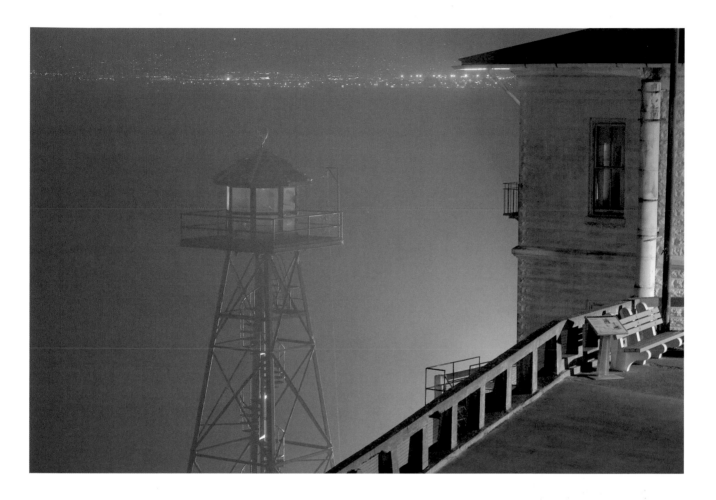

THOM SEMPERE TOWARD SAN FRANCISCO, MIDDLE OF THE NIGHT

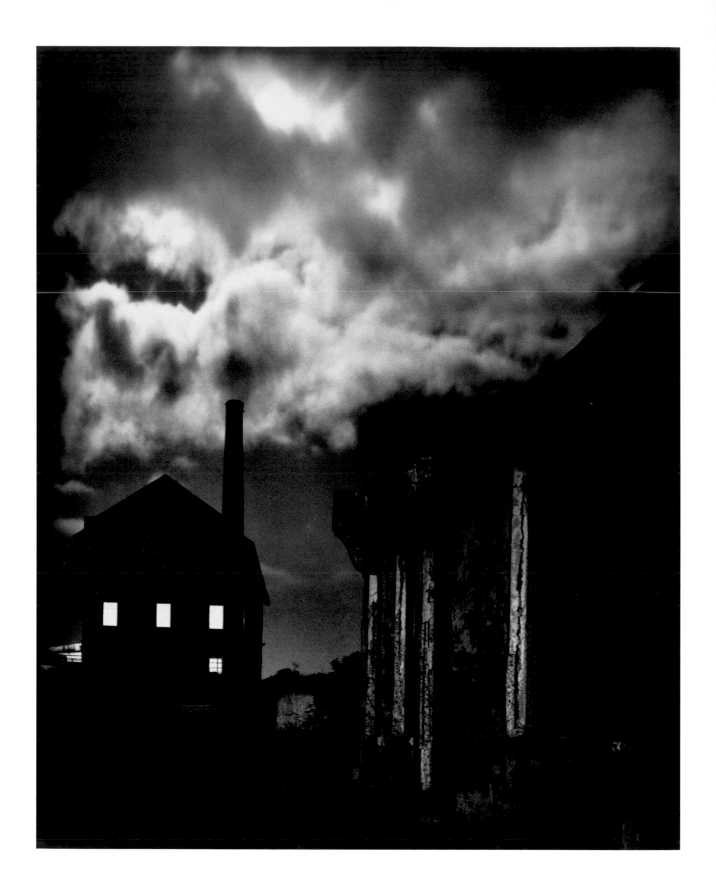

MICHAL VENERA UNTITLED

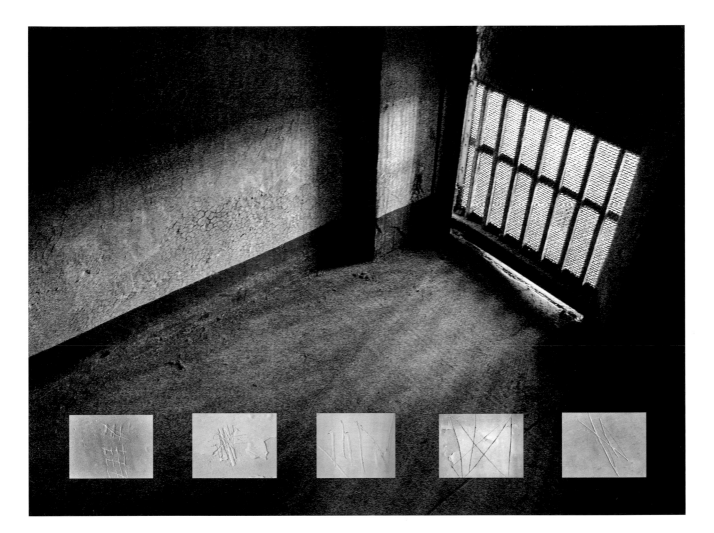

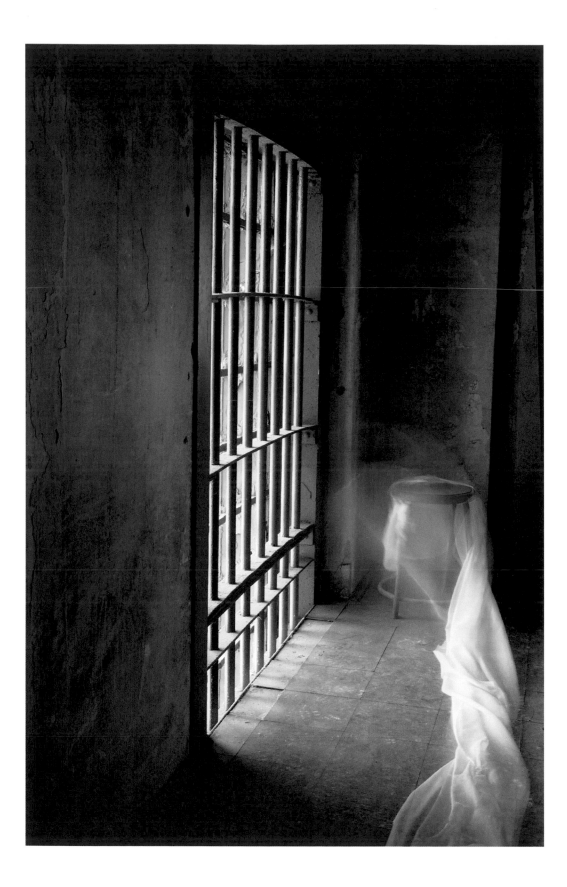

DEBORAH ROUNDTREE THE GUARD'S STATION

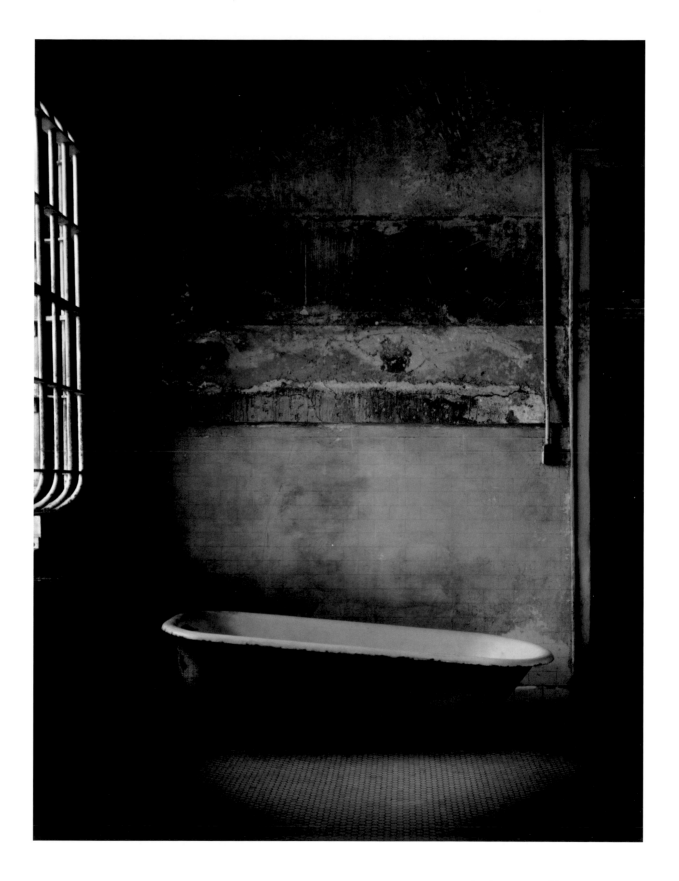

MICHAL VENERA UNTITLED

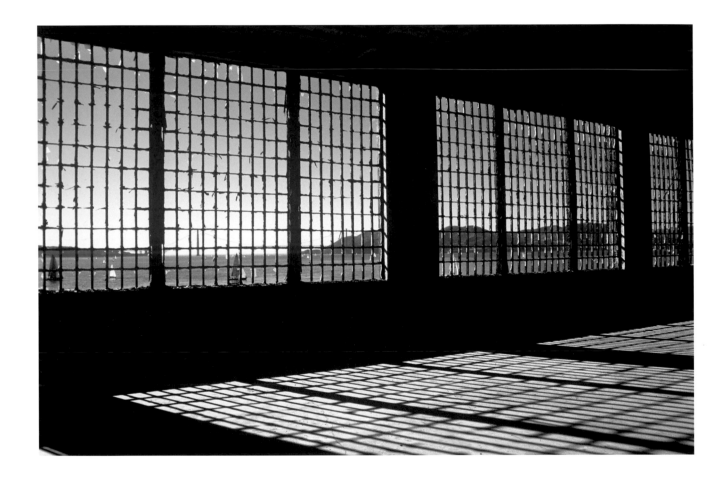

ELLEN CHANG THE TURQUOISE GRID

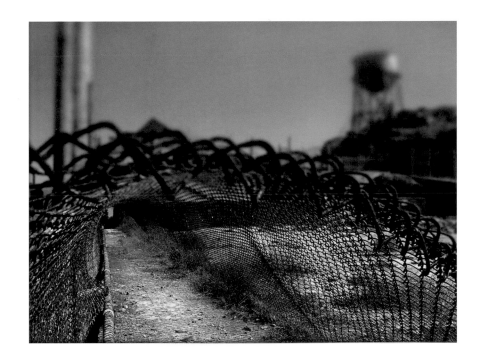

REBECCA MARTINEZ WIRE TUNNEL IN A REMOTE AREA

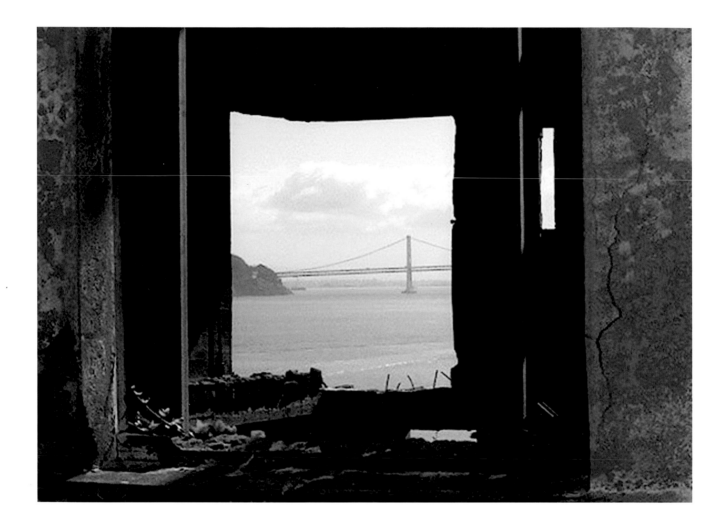

CAROLYN FRANZEL THE WARDEN'S HOUSE

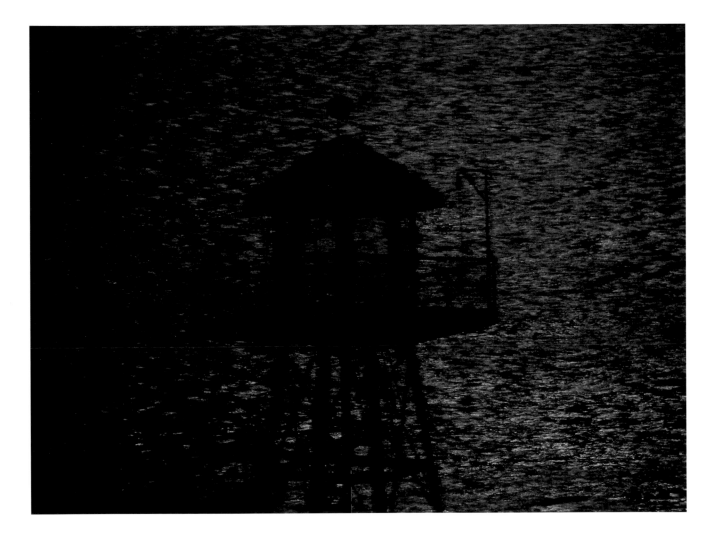

JAMES SEMPERE NIGHT WATCH—GUARD TOWER IN FRONT OF BARRACKS BUILDING NO. 64

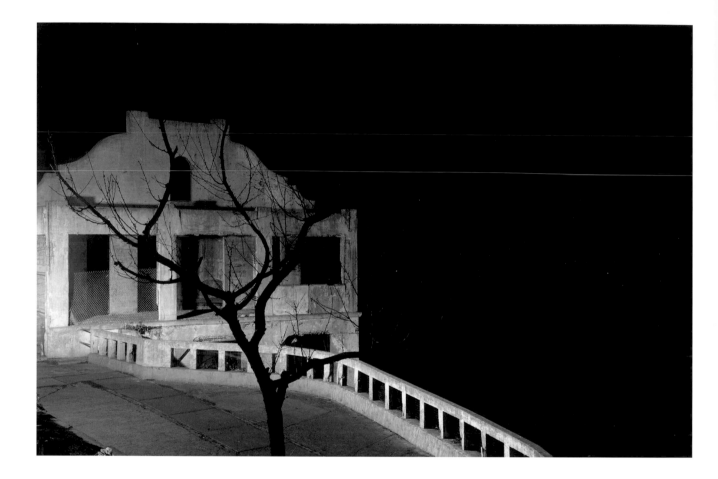

DEBORAH ROUNDTREE SOCIAL CLUB BUILDING

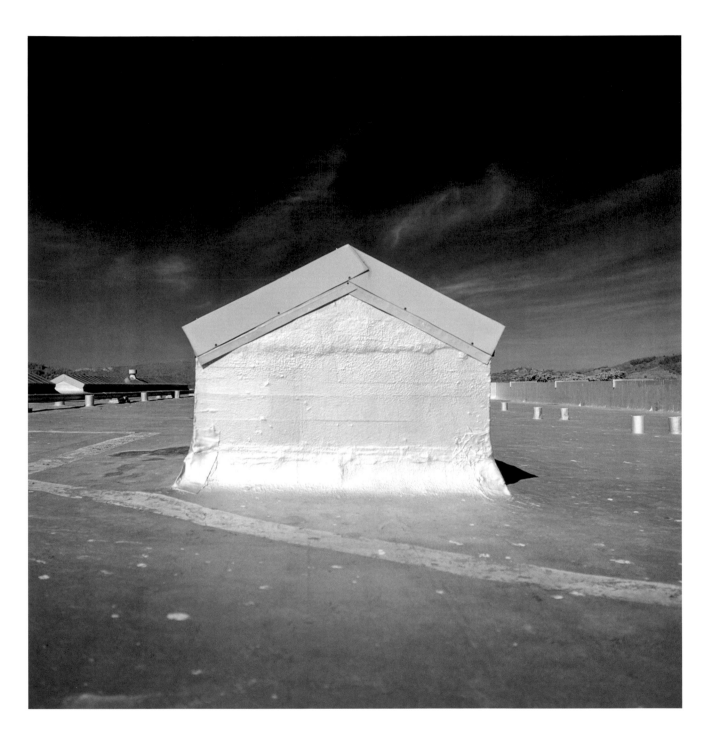

HENRIK KAM CELLHOUSE ROOF SHED

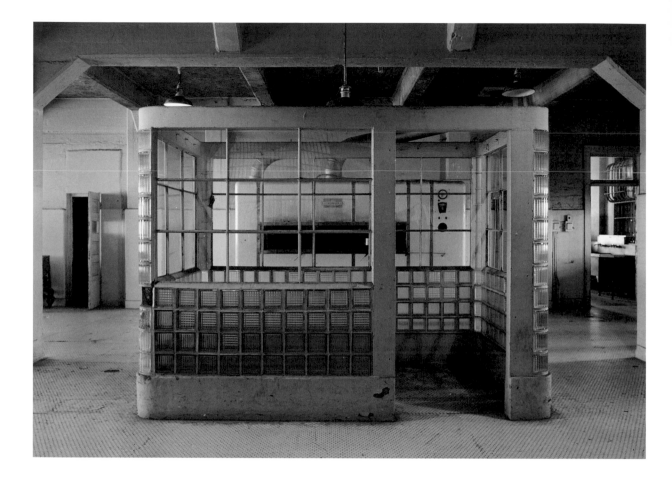

ROSS CAMPBELL THE CHEF'S OFFICE

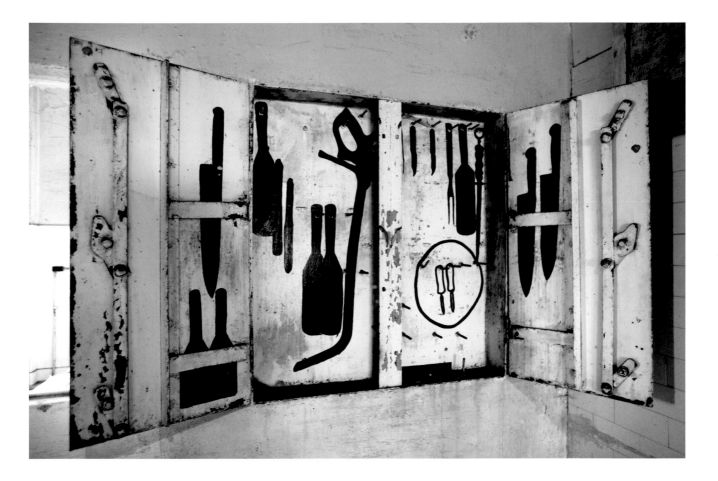

DEBORAH ROUNDTREE UTENSIL AND KNIFE BOX, KITCHEN

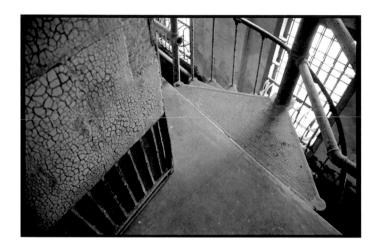

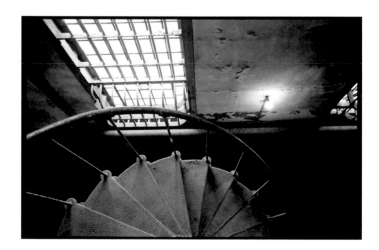

JASON SHELDRICK DESCENT/SECOND STORY CELL DOOR AND SPIRAL STAIR

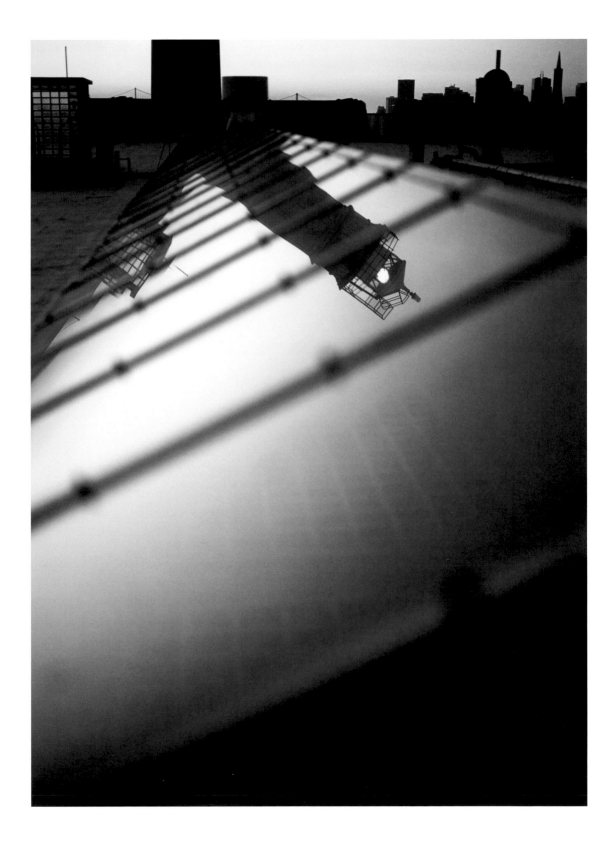

BRIAN WARSHAWSKY CELLBLOCK SKYLIGHTS AT SUNRISE, LIGHTHOUSE, AND SAN FRANCISCO

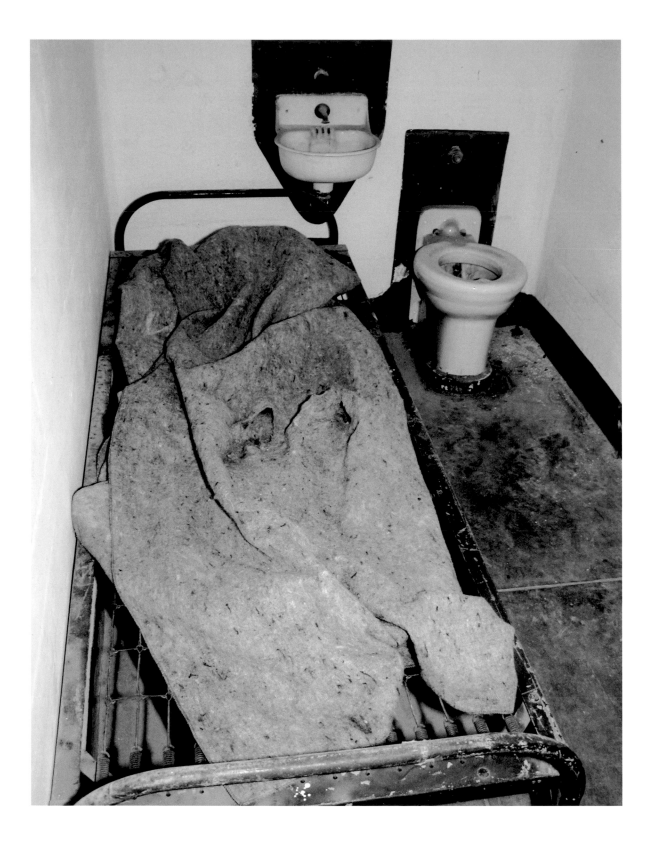

STEVE FRITZ ROOM WITH NO VIEW

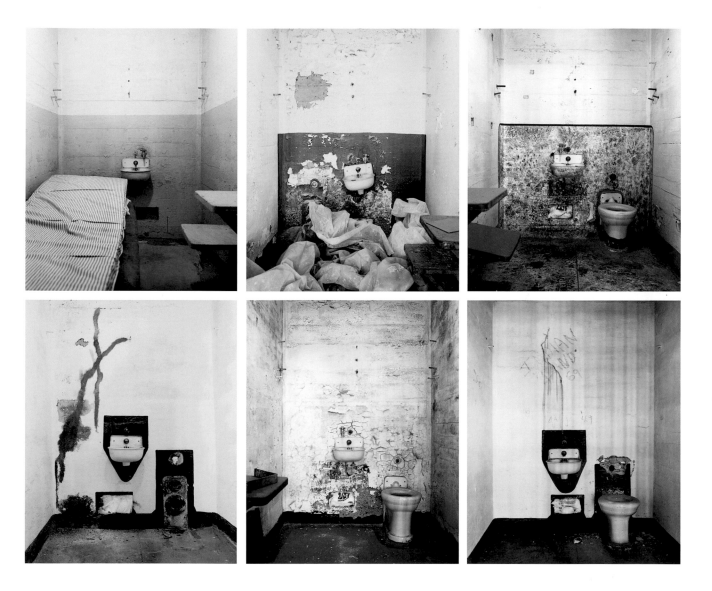

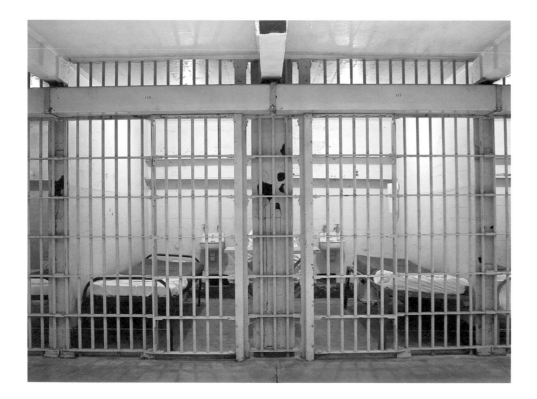

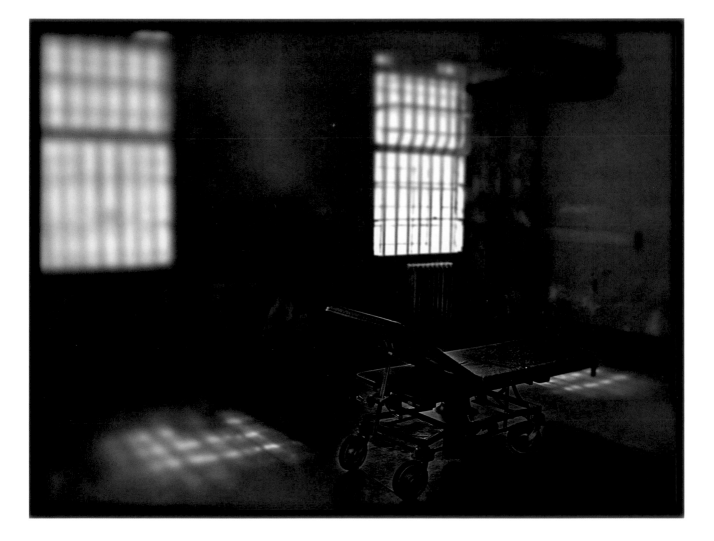

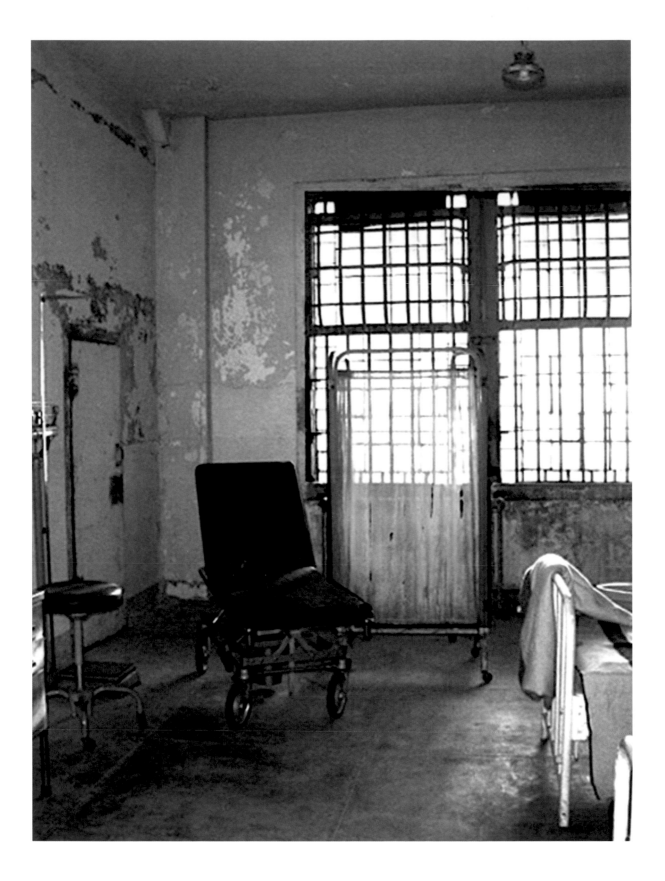

CAROLYN FRANZEL HOSPITAL/EXAM ROOM

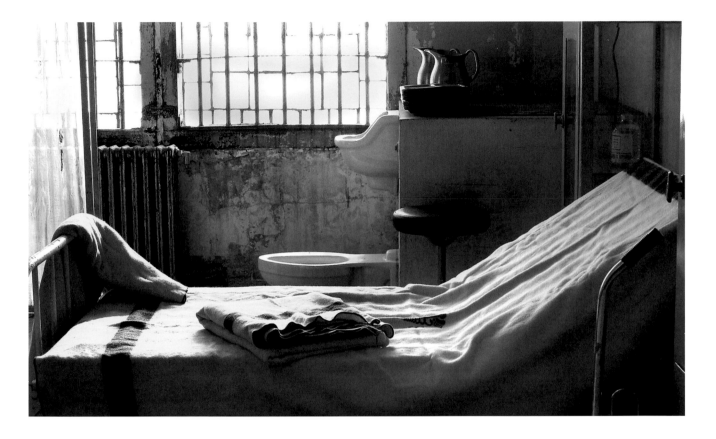

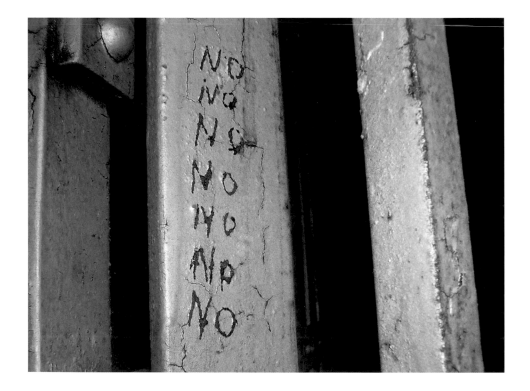

DANNI SEMPERE NO, NO, NO . . .

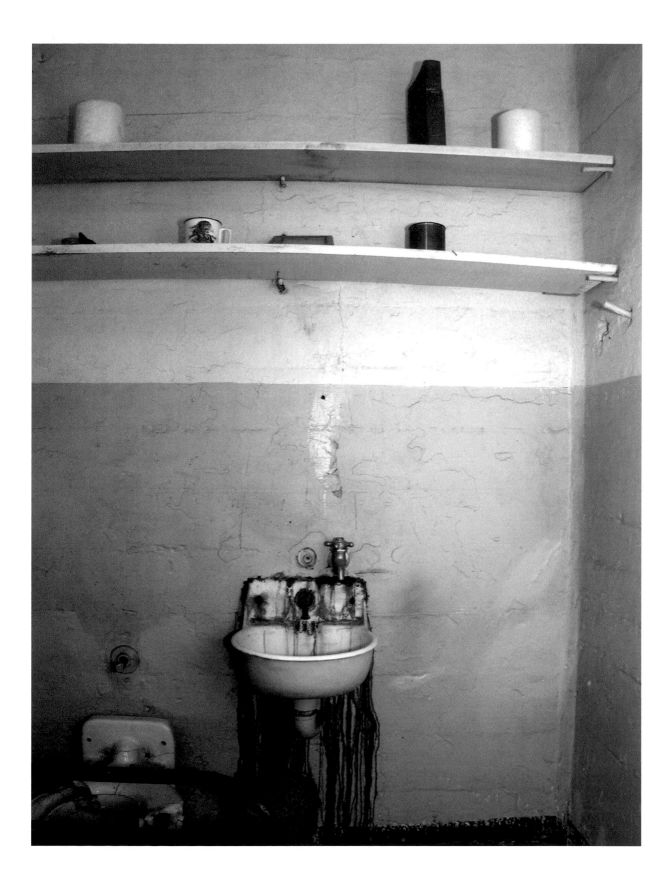

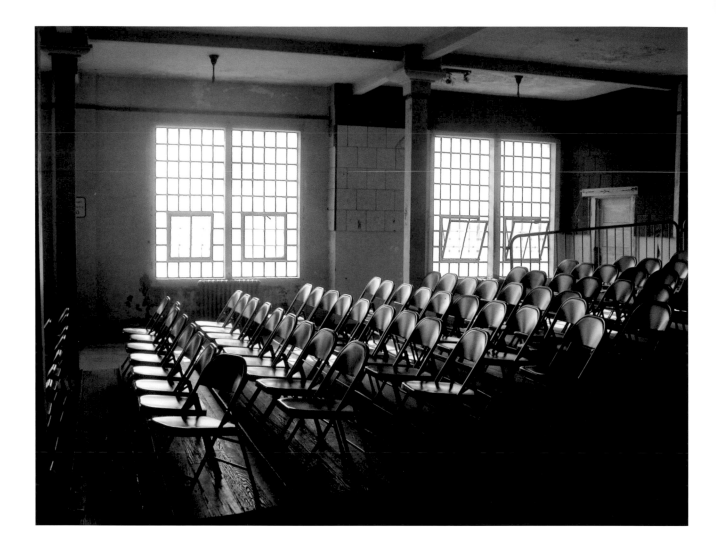

STEVE FRITZ PRISON CHAPEL

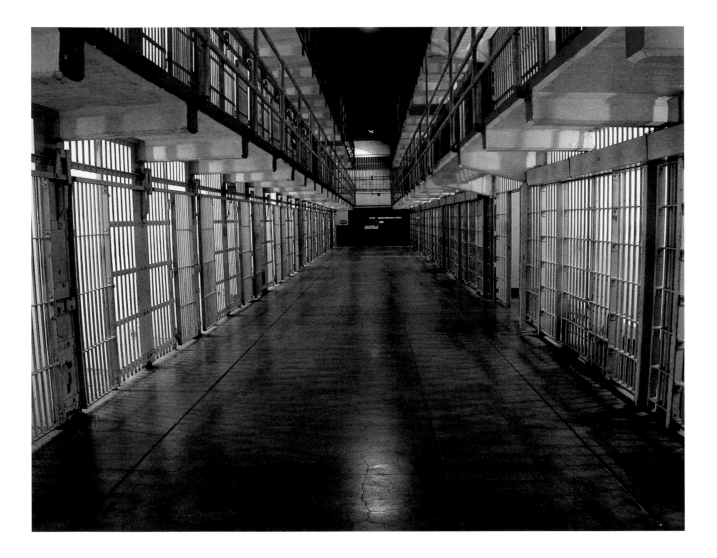

STEVE FRITZ STARK VIEWS DOWN THE CELL BLOCK

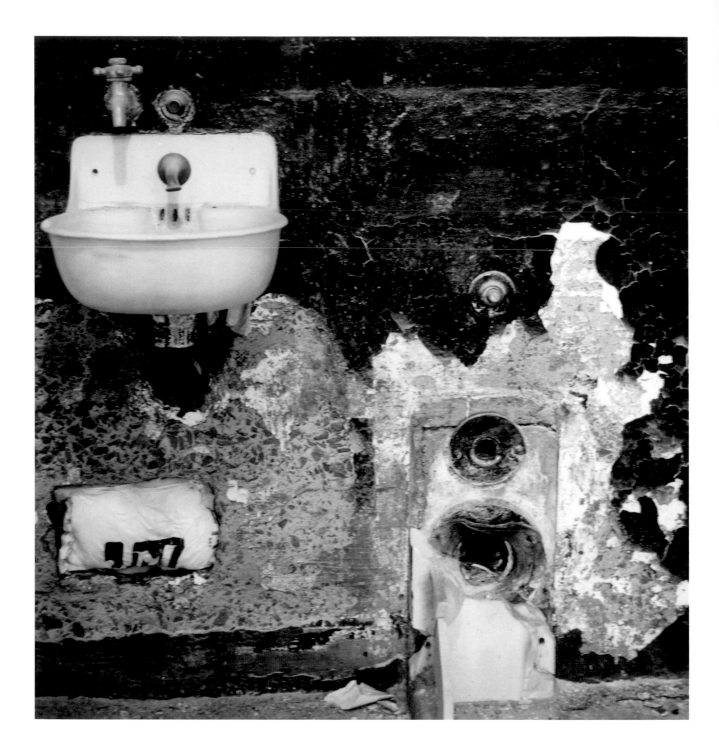

HUGH LINN CELL WALL, BLOCK B, SECOND FLOOR

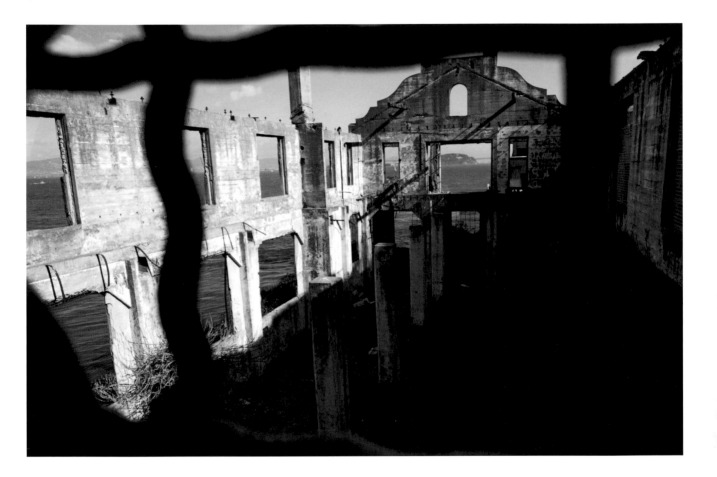

DAN KATZMAN THE OFFICERS' CLUB

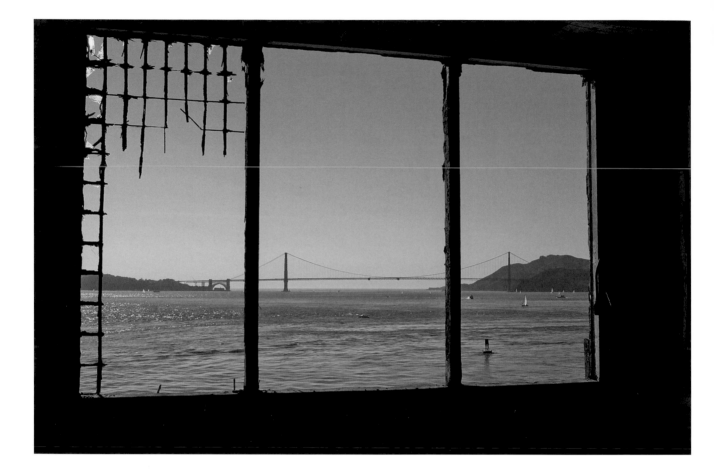

RALPH WILSON THE GOLDEN GATE BRIDGE, SYMBOL OF SAN FRANCISCO

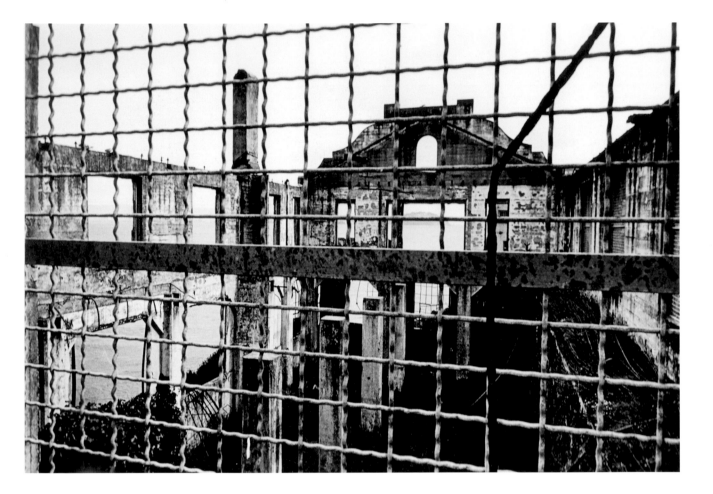

HUGH LINN WARDEN'S HOUSE

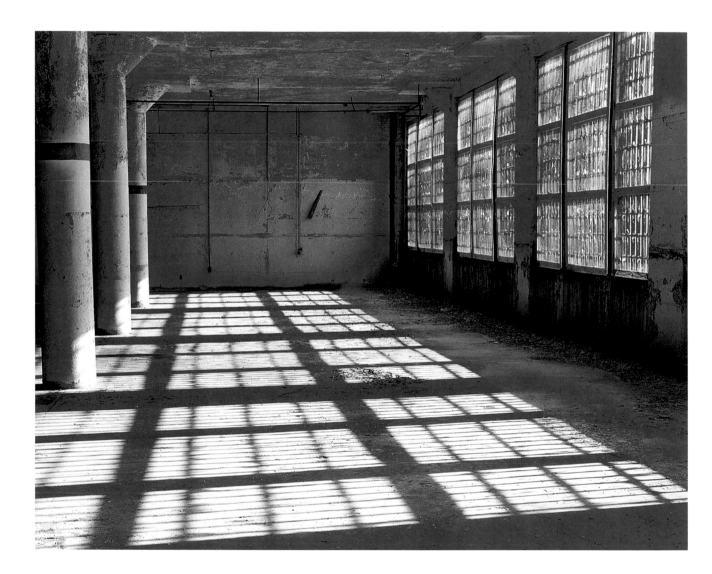

MARK ROH ABANDONED LAUNDRY ROOM

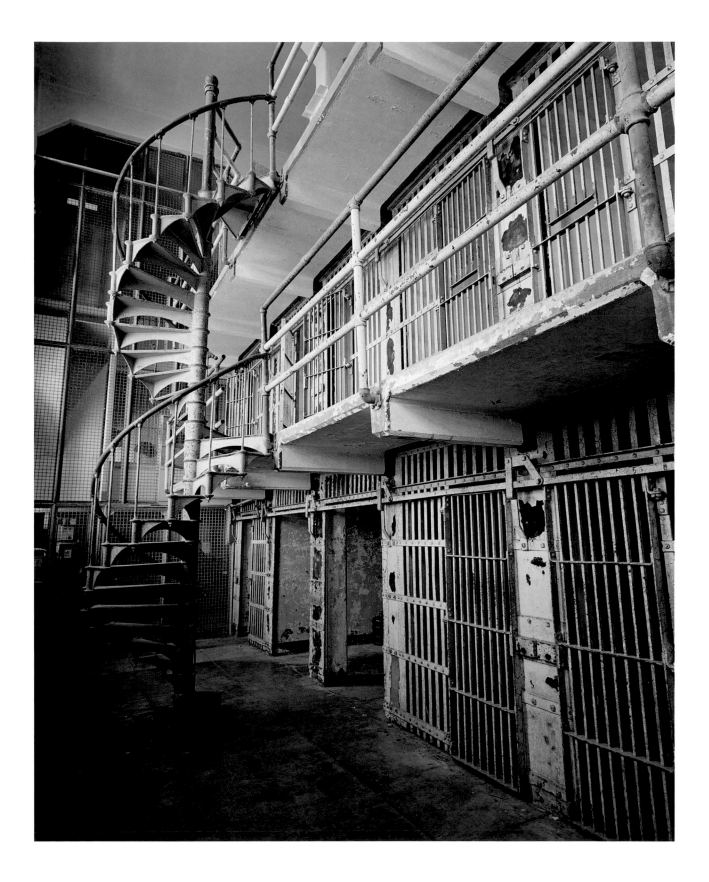

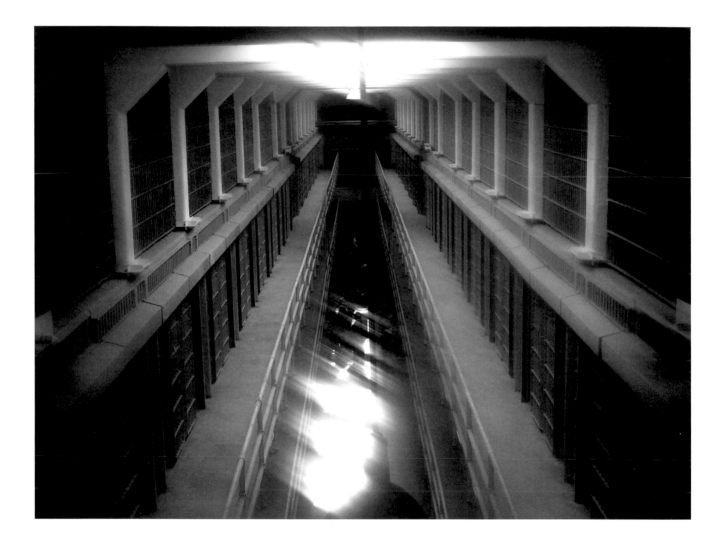

LISA MULLERAUH VIEW FROM ABOVE B BLOCK

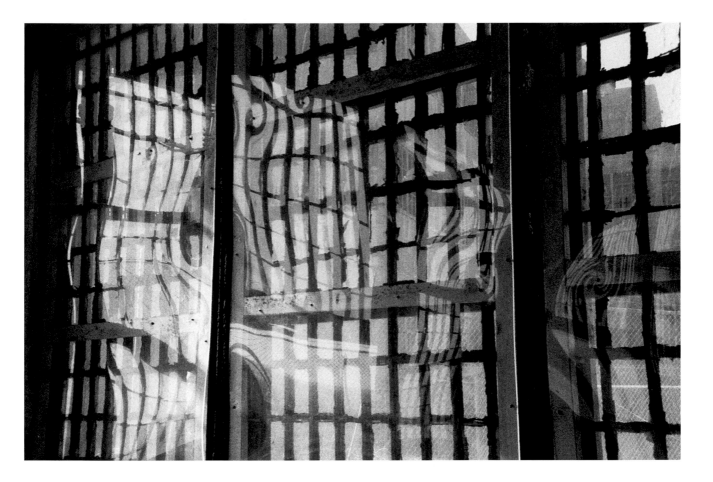

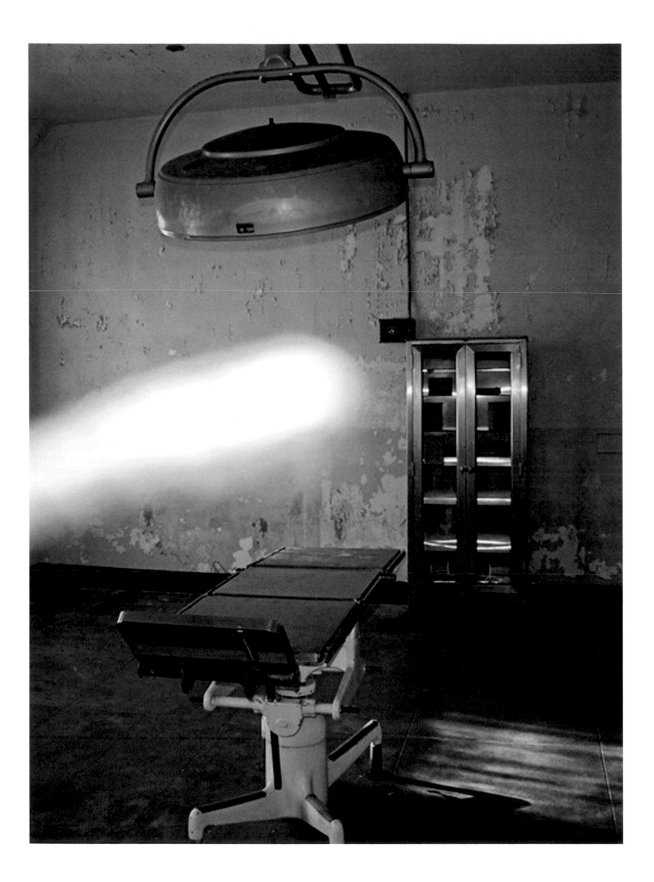

CAROLYN FRANZEL APPARITION FLOATING ABOVE THE OPERATING TABLE

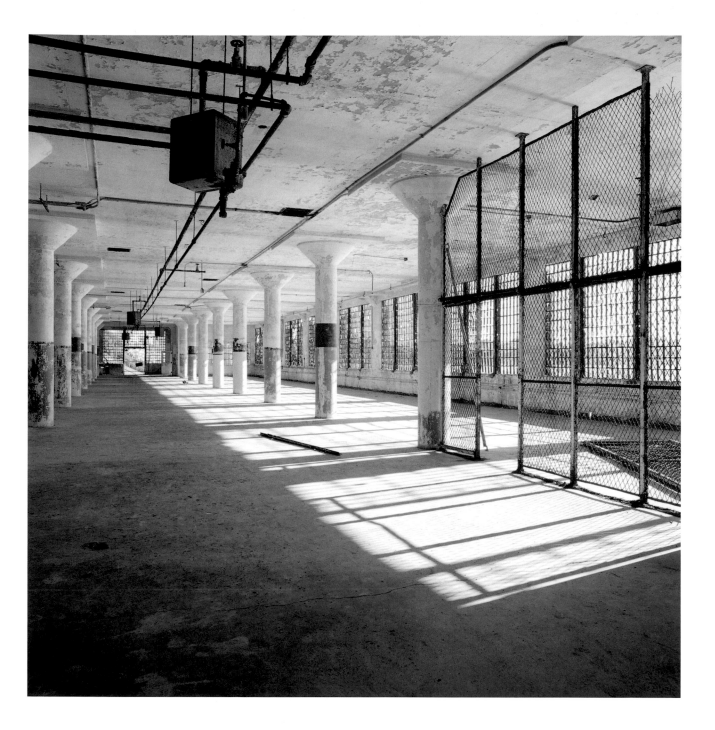

HENRIK KAM CAGE AND HEATER, NEW INDUSTRIES BUILDING

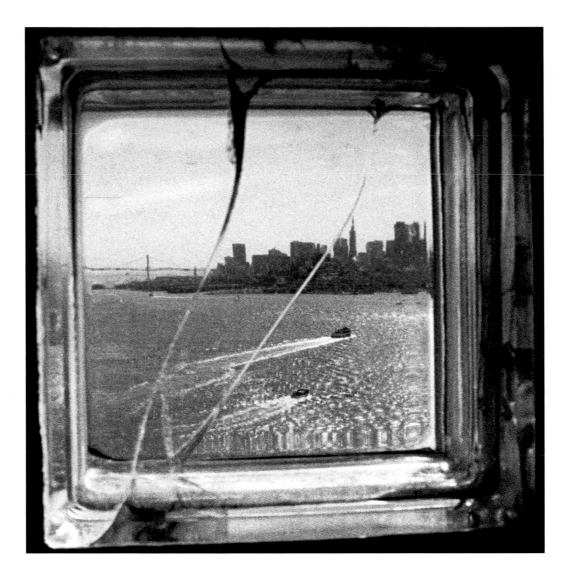

ELLEN CHANG THE V-SCAPE OF ALCATRAZ

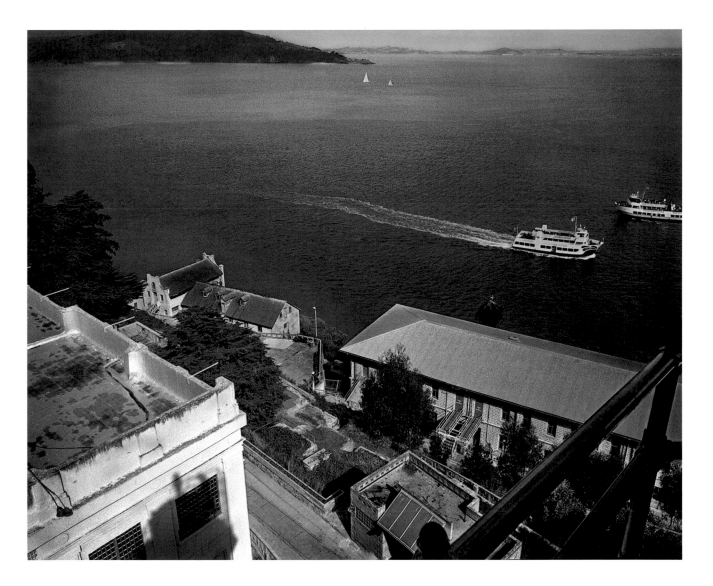

MARK ROH PATH THAT EACH INMATE TRAVELED FROM THE BOAT TO HIS NEW HOME

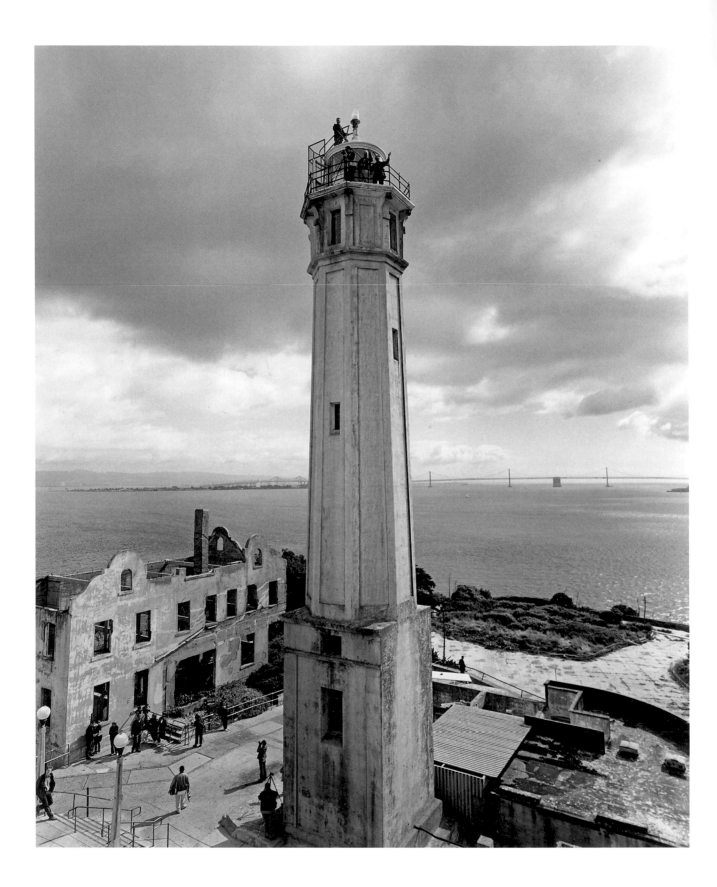

ROBERT DAWSON LIGHTHOUSE WITH THOM ON TOP AND BAY

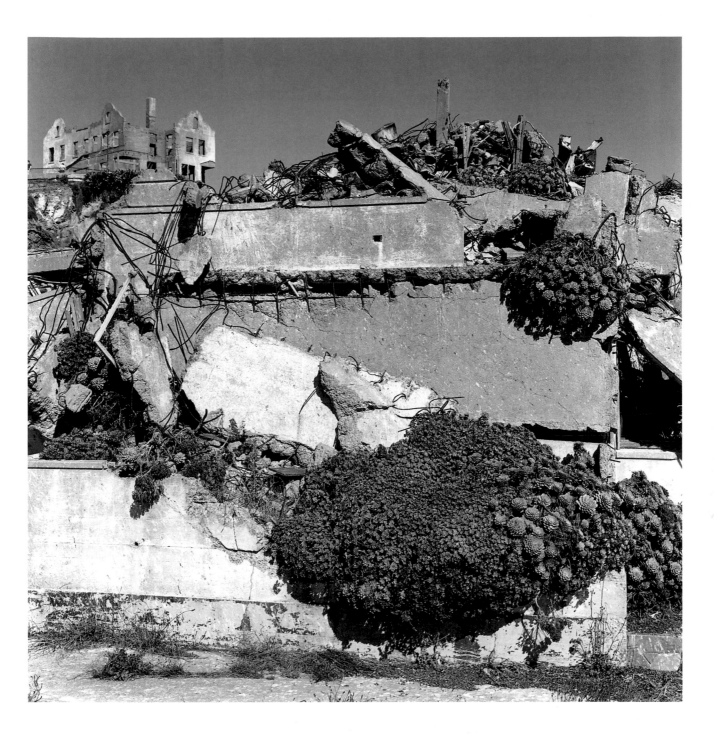

ANTON ORLOV DEBRIS OF OLD SERVICE QUARTERS

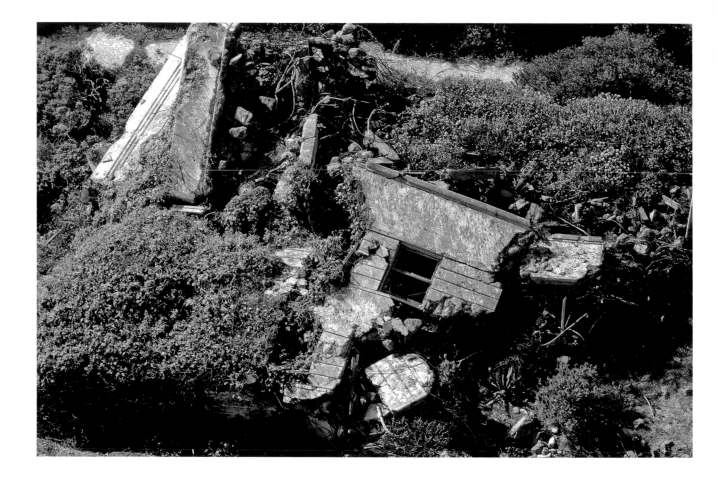

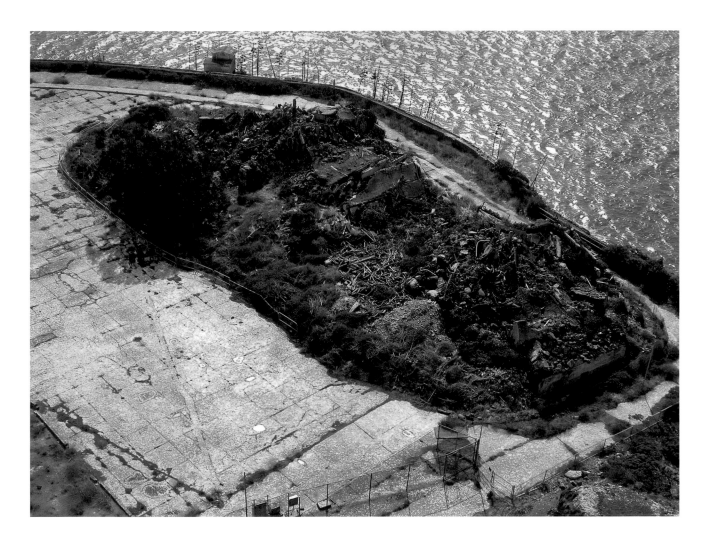

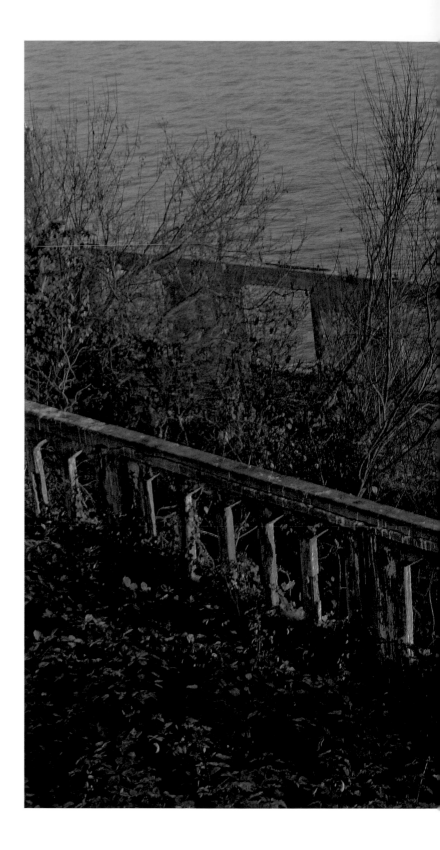

THOM SEMPERE FIRST LIGHT OF DAY

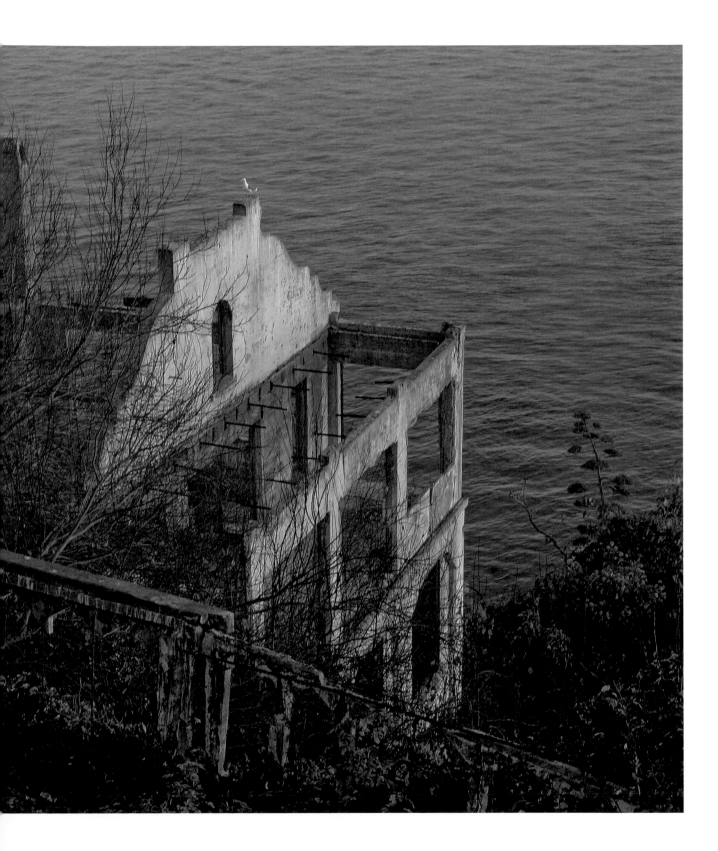

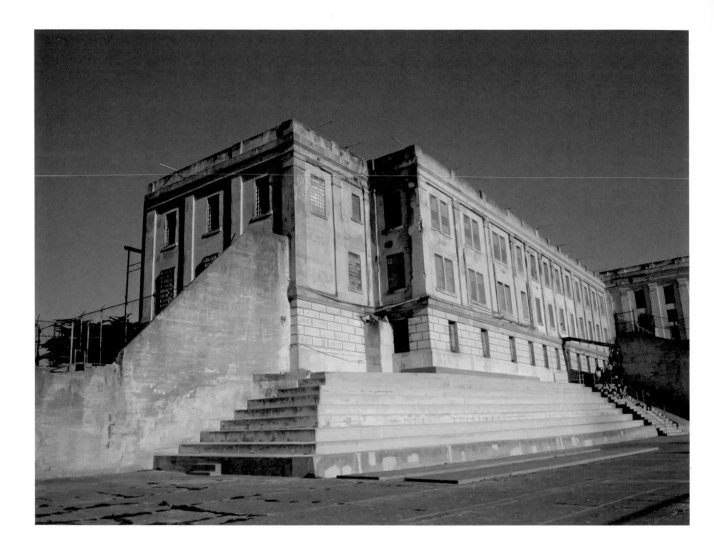

THOM SEMPERE FROM THE EXERCISE YARD

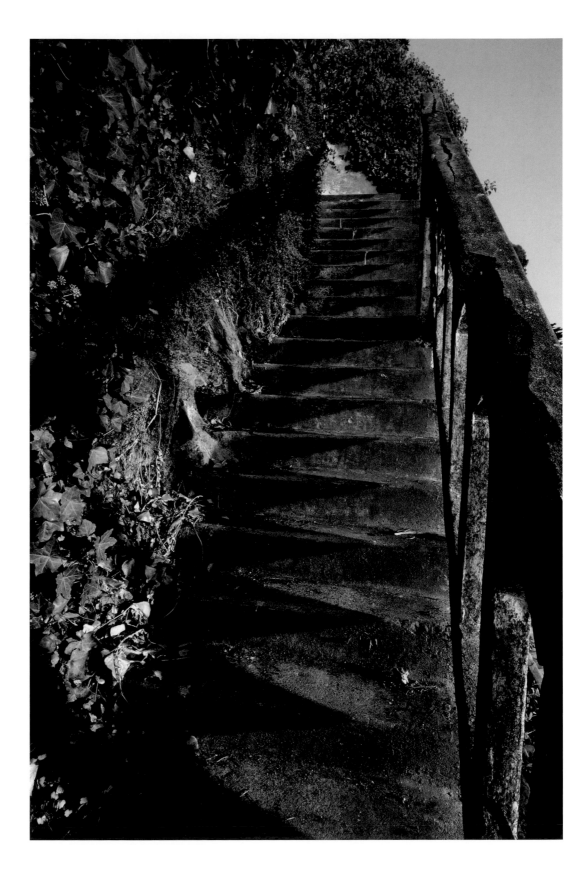

DAN KATZMAN EASTERN STAIRS AT FIRST LIGHT

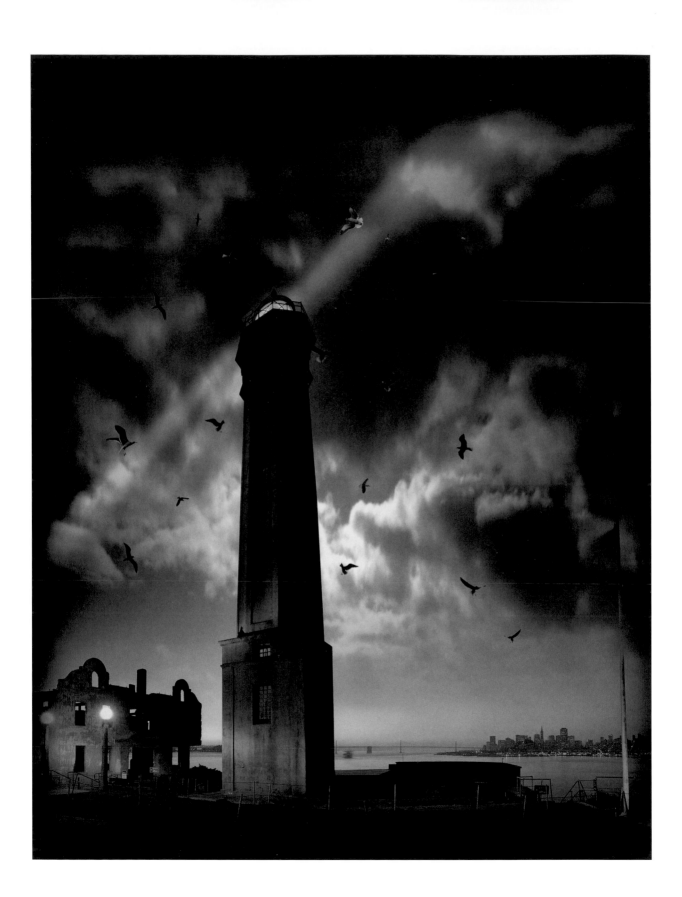

MICHAL VENERA UNTITLED

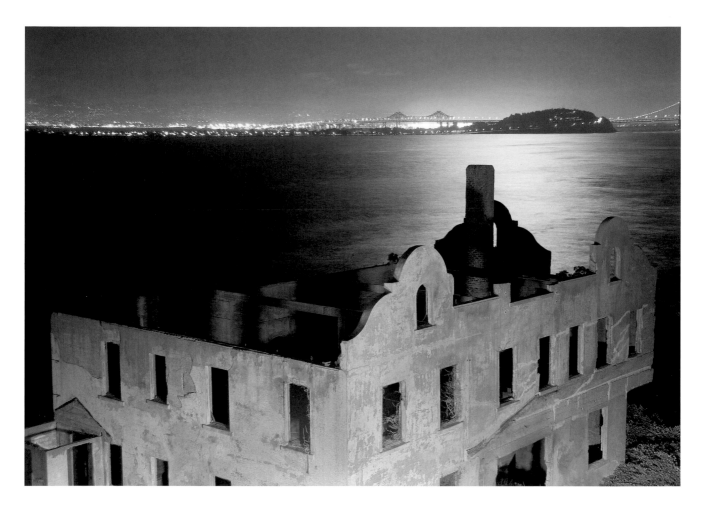

ADAM PAPIER WARDEN'S HOUSE SEEN FROM THE ROOF OF THE PRISON/BAY BRIDGE IN BACKGROUND

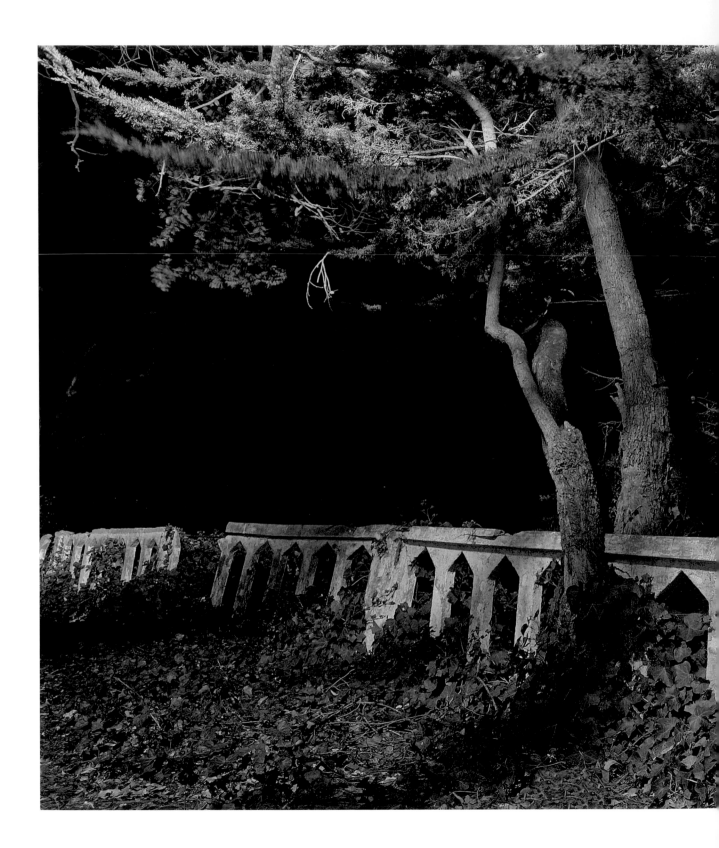

THOM SEMPERE THE SLOW PASSAGE OF TIME

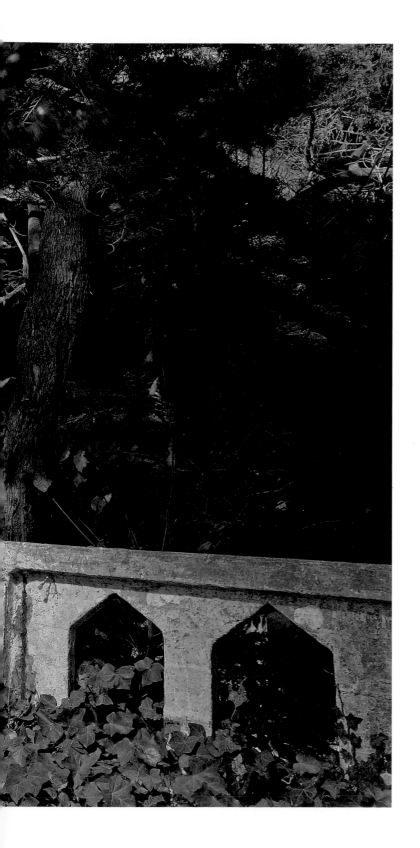

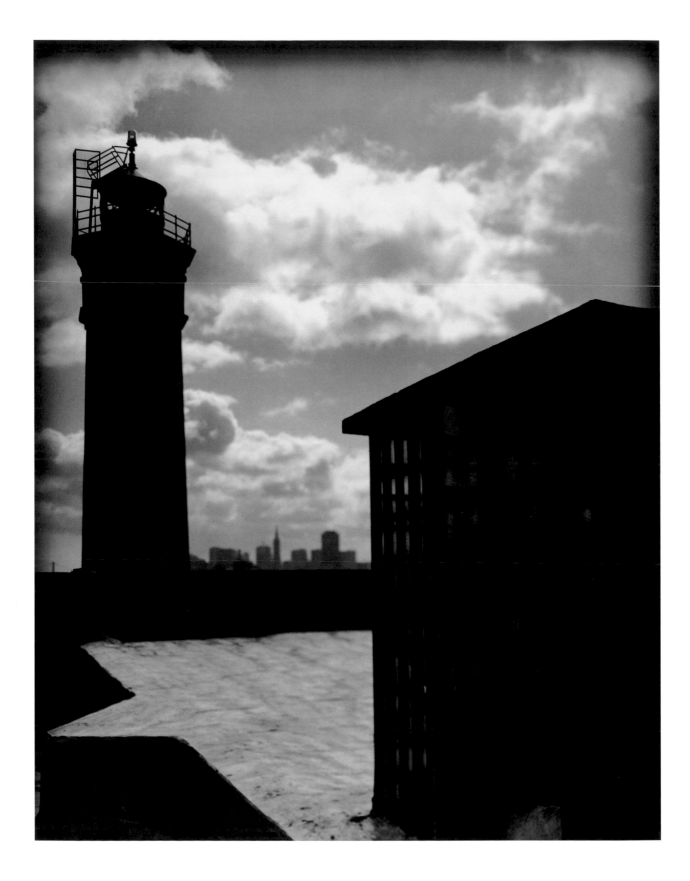

MICHAL VENERA UNTITLED

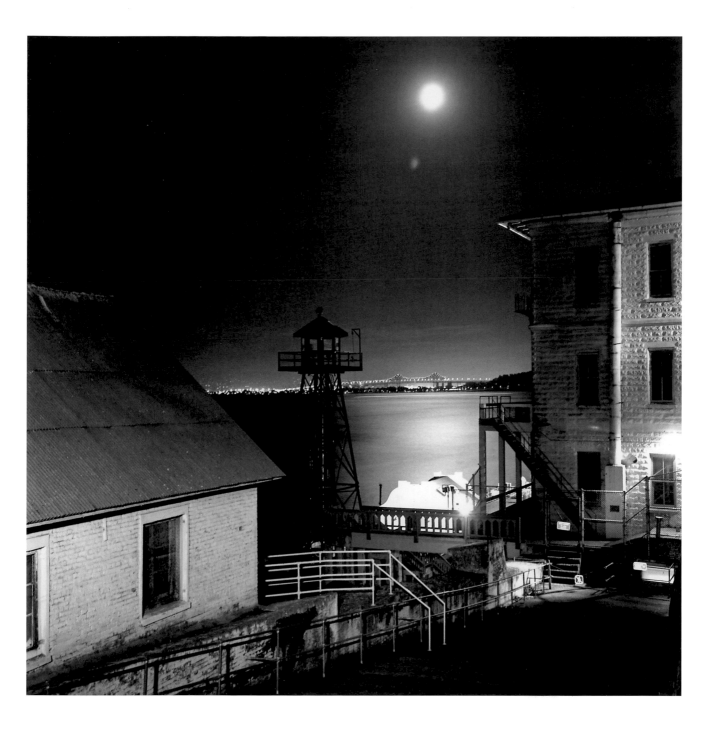

ANTON ORLOV WATCH TOWER AT NIGHT WITH VIEW OF BAY BRIDGE

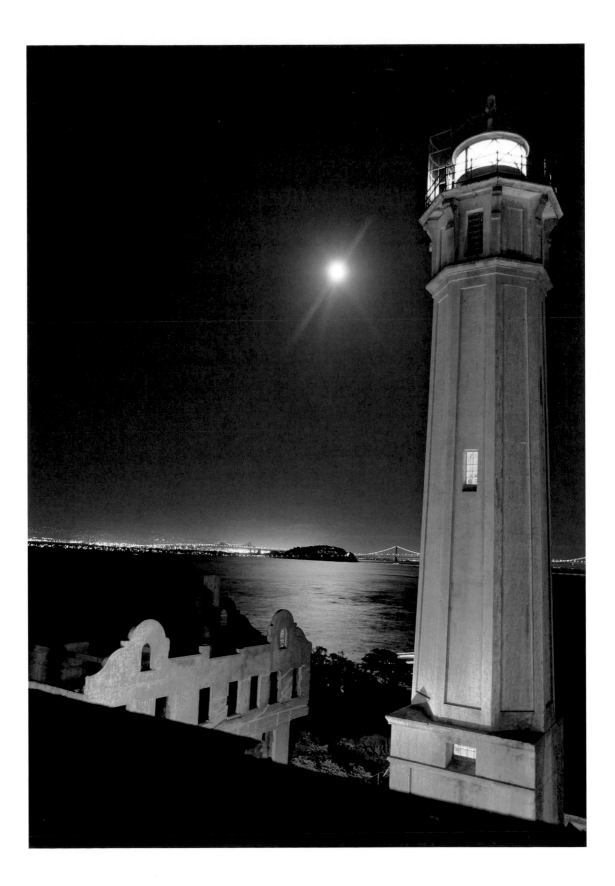

DEBORAH ROUNDTREE VIEW OF TOWER AND BAY BRIDGE, FROM ROOFTOP

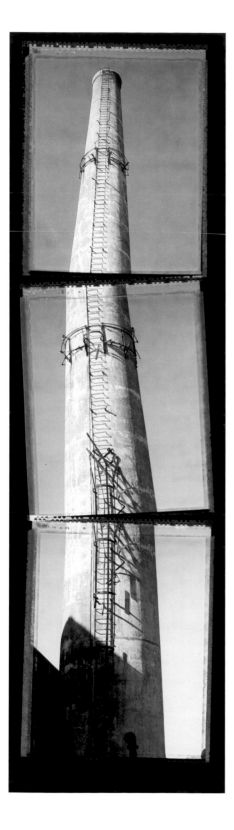

ANTON ORLOV SMOKE STACK

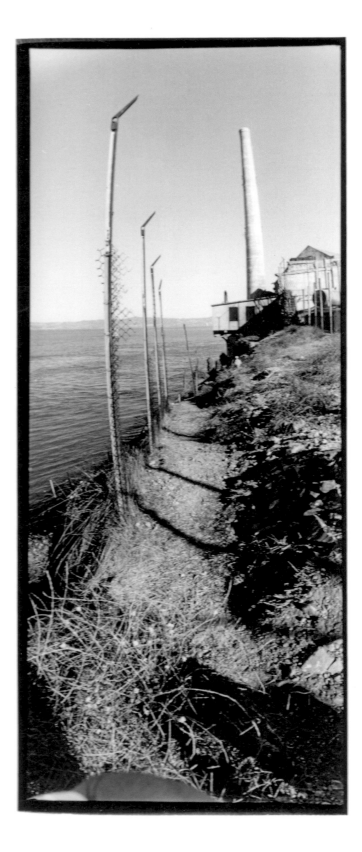

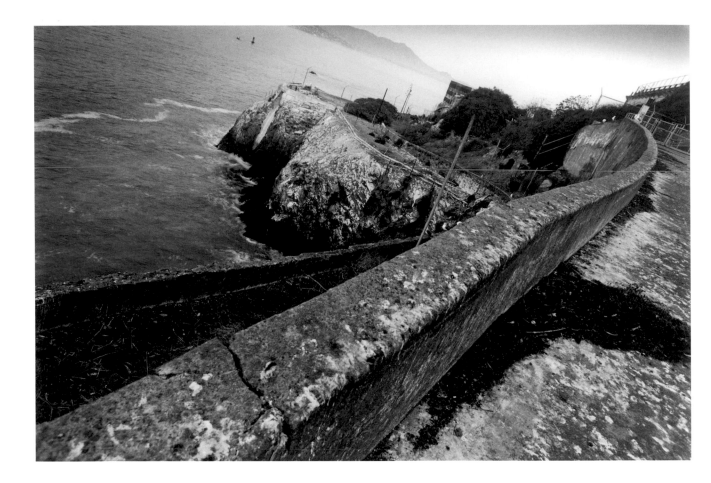

LYNNE BUCKNER GULL HANGOUT

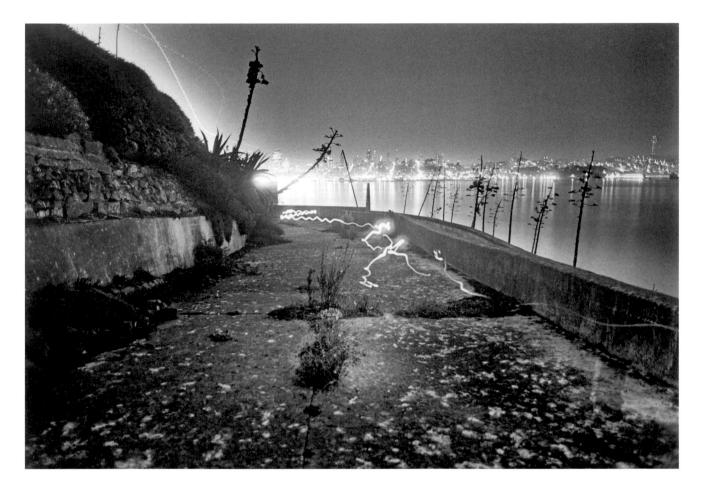

LYNNE BUCKNER IMAGINING GHOSTS. CITY VIEW AT 5 A.M.

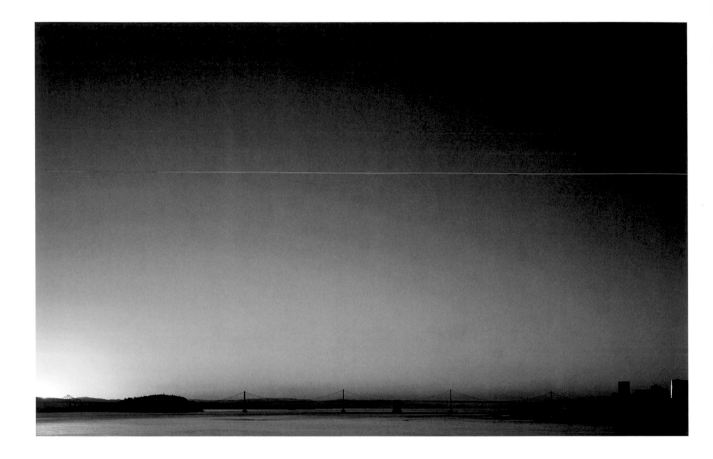

STEVE VANCE SUNRISE, BAY BRIDGE FROM ALCATRAZ

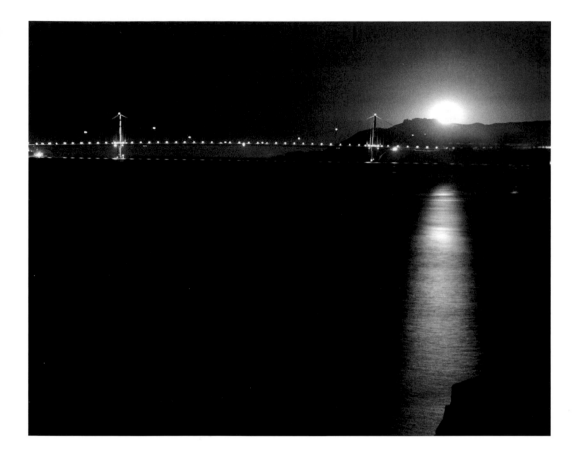

MARK ROH MOON DESCENDING OVER GOLDEN GATE BRIDGE, 4 A.M.

MICHAL VENERA UNTITLED

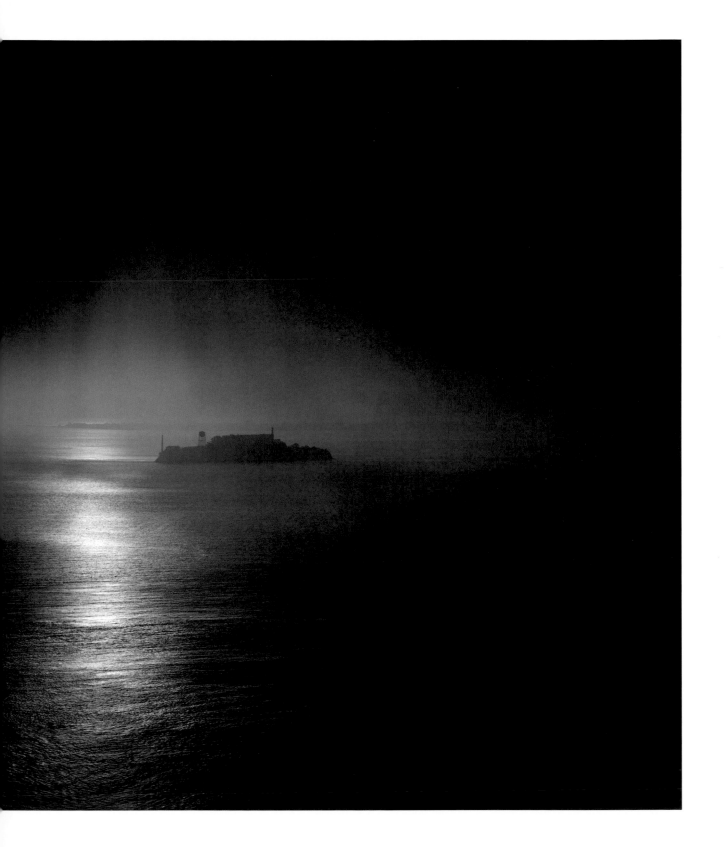

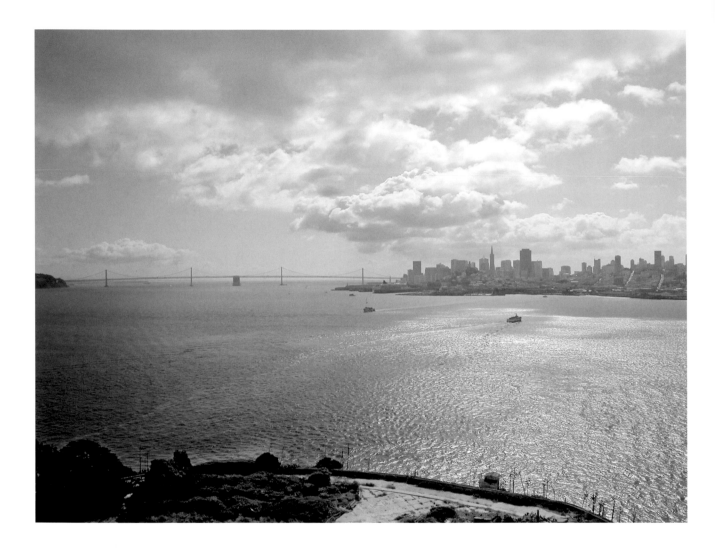

THOM SEMPERE FROM THE PRISON ROOFTOP, FERRY BOAT EXCHANGE

ALCATRAZ IS A STUDY IN CONTRASTS AND CONTRADICTIONS. Its unique geography and history make it both compelling and complex. The physical isolation of the island in the midst of the cold, rough waters of San Francisco Bay, in proximity to one of America's most beautiful cities, and the long and varied history of the island make it one of the most fascinating pieces of American antiquity.

Hidden Alcatraz represents one manner of coming to terms with the challenge that is Alcatraz. It is a storybook of sorts, comprised primarily of photographic images made by the participants in a series of field workshops organized by PhotoAlliance, a Bay Area–based nonprofit organization dedicated to supporting the understanding, appreciation, and creation of contemporary photography.

Photography has a rich place in Bay Area history. Many of the finest camera artists have lived and worked in the region, some of the best museums and galleries are located here, and the dynamic environment quickens the artistic impulse. Over three successive years, PhotoAlliance, with support from the Golden Gate National Parks Conservancy, held a series of field workshops on Alcatraz Island, led by Robert Dawson, a highly respected teacher and gifted photographer. The workshops were open to all ages and levels of experience, the only requirement being a sense of adventure and openness. From teens to retirees, advanced hobbyists to professionals, the participants were a diverse and energetic lot, and arrived armed with everything from small point-and-shoot digital cameras to very complex large-format 8 x 10 view cameras.

Each October, just after the gulls gave back large parts of their summer nesting grounds to visitors, the thirty or so workshop participants arrived on the first morning ferry. They stayed on after the last tour boat left, then had the remains of

the day and the entire night to explore and photograph the island. Park service rangers accompanied the group, providing historical background and access information—particularly important due to the "arrested decay" (a poetic way of describing slow disintegration due to corrosive salt air and the philosophy of the Park Service that to overly preserve or intervene is to deny history) of the historic buildings and the dynamic topography on which they lay.

The workshop photographers were given access to places off the normal day ticket tour: up to the prison roof and lighthouse; the hospital; the industries building; the tunnels; the morgue; the cell blocks and even the rumored "dungeon" beneath them (there isn't one). At midnight everyone was provided accommodation to rest in if they chose: a jail cell to await the dawn (unlocked of course)!

Some slept fitfully, while others continued to photograph throughout the night. Utilizing tripods and long exposures, flash or portable lights with gels, and working from a host of perspectives and sensibilities, the photographers discovered new and unimagined views of the island. The result is an attractive and persuasive collection of pictures, as multifaceted as Alcatraz itself. We find here traditional black-and-white and color prints, along with digital, hand-colored, and otherwise manipulated responses.

Some of the photographs are in the documentary tradition, capturing factual, descriptive or empirical visions. Others manifest as art, expressing subject as metaphor, allegory, or symbolism. Between these two poles, a photograph can act as a window open to the world or as a mirror held up to the inner self, and thus offers a limitless wealth of material.

I entreat you, the viewer, to experience this collection of photographs produced by a diverse set of artistic intents and individual talents in a myriad of ways: as a guidebook; as a catalog of creative techniques; as a history lesson; or as a compilation of eclectic postcard views. Then, I leave you to ponder how creativity can be set loose by a place notorious for its harsh and restrictive environment and history. Thus is the poetic contradiction of Alcatraz Island, otherwise known as the Rock.

STEVE FRITZ

Steve Fritz is a fine art photographer with a master's degree from the University of Oregon. He has lived in the San Francisco Bay Area for over fifteen years. He previously operated a commercial photography studio in Los Angeles, serving clients such as N.W. Ayer, Yamaha, McCann-Erickson, Grey Advertising, McKesson Drugs, *Newsweek*, and Chase Manhattan Bank; he subsequently has continued to use his creative skills in high-tech marketing with a variety of innovative Silicon Valley companies. Specializing in photographs of landscapes, nature, abandoned properties, rotting equipment and old vehicles for over two decades, he has had numerous one-man and group shows in northern California and Oregon.

Along with Deborah Roundtree, Fritz has worked to turn the *Hidden Alcatraz* project into a book by nurturing relationships with the Alcatraz and National Park Service personnel responsible for the island's management, and by creating the publishing proposal. He says, "I was drawn to Alcatraz by the opportunity to spend a weekend photographing and sleeping in the most infamous prison in the world, and the chance to meet and work with other Bay Area photographers, and together explore the photographic richness and possibilities of the island."

DEBORAH ROUNDTREE

As the founder and creative director of Roundtree Visuals, Deborah has set new trends in advertising and digital photography for Fortune 500 companies for over twenty-five years. Roundtree's work is in the permanent collections of the Library of Congress, Disney Corporation, Kaiser Permanente, Hasselblad, Bibliothèque Nationale, Paris, and Sir Paul McCartney. She has had group and solo exhibitions at London's Museum of Science, the Sydney Opera House, and UNESCO headquarters in Australia, the Metropolitan Transportation Authority "Arts for Transit," New York, and Daniel Saxon Gallery, Los Angeles. She is a recipient of a National Endowment for the Arts award, and a Brody Fellowship, and her work has been featured in *Graphis*, *PRINT* and *Communication Arts* magazines.

Along with Steve Fritz, Roundtree has been the driving force behind turning the Alcatraz project into a book, collecting and organizing hundreds of images from the participating photographers. She says, "These eloquent and haunting images capture Alcatraz in a way that few will ever see. They strip away its glamour, exposing its broken and desolate complexities, and offer us a rare opportunity to experience this place of mystery and lost promise."

PETER COYOTE

Peter Coyote has performed as an actor for some of the world's most distinguished filmmakers, including Barry Levinson, Roman Polanski, Pedro Almodovar, Steven Spielberg, Walter Hill, Martin Ritt, Steven Soderberg, Diane Kurys, Sidney Pollack and Jean-Paul Rappeneau. His memoir of the 1960s counterculture, *Sleeping Where I Fall,* received universally excellent reviews, appeared on three best seller lists, sold five printings in hardback, and was reprinted with a new cover and afterword in 2009. A chapter from that book, *Carla's Story,* won a 1993–94 Pushcart Prize for Excellence in Non-fiction. From 1975 to 1983 he was a member and then chair of the California State Arts Council. During his tenure as chair, expenditures on the arts rose from 1 to 16 million dollars annually. An ordained Buddhist who has been practicing for thirty-four years. Coyote also has been engaged in political and social causes since his early teens.

JOHN MARTINI

John Martini began his twenty-five-year career as a National Park Ranger on Alcatraz Island in 1974. He has spent more than thirty-five years researching the island and its occupants, and is regarded as the preeminent expert on the island's history. The author of two books, *Fortress Alcatraz: Sentry At the Golden Gate* and *Alcatraz At War,* he is currently working on a book about artifacts from the island now residing in the museum collection of the National Park Service.

THOM SEMPERE

Thom Sempere has been actively involved with the arts community in the Bay Area since 1977. He holds an M.F.A. in photography from the University of Washington and undergraduate degrees from the University of Michigan and the San Francisco Art Institute. He is currently the executive director of PhotoAlliance, an organization dedicated to supporting contemporary photography, which sponsored the original workshops on Alcatraz that led to the creation of this book. He also teaches history of photography and studio courses at the San Francisco Art Institute, and has been a visiting faculty member at Stanford University in the Art and Art History Department.

He says, "Alcatraz is inherently compelling. For those of us who live in the Bay Area, it is a sight constantly caught in our peripheral vision. It also has inserted itself into our cultural consciousness by being notorious. So the opportunity to set foot on the island as one of the organizers of the series of photography workshops from which this book evolved—and as a photographer—was irresistible. The footprint of man there is heavy and foreboding, but what is often lost when one thinks about the crime and punishment embodied there is the equally monumental beauty that the place holds physically."

SALLY ALLEN

Sally Allen learned about photography when she accepted her first job as a reporter at a weekly newspaper where, in addition to writing and editing, she developed and printed photographs. She subsequently created "Through My Eyes," a digital photography project for underserved elementary school children and, with another photographer, a two-week photography program with middle-school children in a rural industrial community in southern India.

LYNNE BUCKNER

Lynne Buckner specializes in black and white film photography, with an emphasis on night photography and alternative processes. Her work has been featured in San Francisco at Gallery Obscura, Cameraworks, and Rayko Photo Center, and published in the environmental journal of the desert *Survivor*.

ROSS CAMPBELL

Ross Campbell says, "Alcatraz interested me for how it functions as a cultural relic, as a site for pilgrimage. What was once off limits to the public, unseen but for its exterior, is now accessible and transparent. At one time it [the prison] was used to isolate those deemed dangerous to society. It now reminds those who visit that they have the freedom to come and go."

ELLEN CHANG

Ellen Chang was born in Taiwan and raised in Taipei and San Francisco. She is a passionate amateur photographer whose day job is in finance.

PEIKWEN CHENG

Peikwen Cheng's photographs have been exhibited in several international shows, including the 2008 China in Transition, curated by John A. Bennette, at New York's Peer Gallery. He has curated and juried shows for the San Francisco Arts Commission and Stanford University, where he frequently lectured prior to moving to Beijing, China, in 2007.

ROBERT DAWSON

Robert Dawson is a longtime educator and practitioner of the art of photography, and one of the instructors for the workshops from which this book evolved. He is the recipient of a National Endowment for the Arts fellowship, and the Dorothea Lange–Paul Taylor Prize. His books include *Robert Dawson Photographs* (1988); *The Great Central Valley: California's Heartland* (with Stephen Johnson and Gerald Haslam; University of California Press, 1993); *Farewell, Promised Land: Waking From the California Dream* (with Gary Brechin; University of California Press, 1999), and *A Doubtful River* (with Peter Goin and Mary Webb; University of Nevada Press, 2000). His photographs are in the collections of the Museum of Modern Art, New York, the Smithsonian Institution's National Museum of American Art, and the Library of Congress.

NADINE DEFRANOUX

Nadine Defranoux has a background in life science with a Ph.D. in microbiology from the University of Paris, France. Her work has been featured in several group and solo shows in the Bay Area, published in the *San Francisco Chronicle* and the *San Francisco Examiner,* and included in several private collections as well as in the permanent collection at Alcatraz.

PATTY FELKNER

Patty Felkner received her B.F.A. in photography from the San Francisco Art Institute and her M.F.A. in photography from the University of Arizona. She currently lives in Sacramento, teaches photography at Cosumnes River College, and serves on the board of Viewpoint Gallery.

ALEX FRADKIN

Originally an architect, Fradkin switched to photography in 1996, having graduated with an M.F.A. from Columbia College Chicago. His photographs have been exhibited internationally, and are in numerous private, public, and corporate collections, including those of the Art Institute and Museum of Contemporary Photography in Chicago, the Portland Art Museum, and the University of Illinois. His projects, *The Left Coast: California on the Edge,* and *Bunkers: Ruins of War in a New American Landscape,* are scheduled for publication in the spring of 2011 respectively by the University of California Press and Radius Books.

CAROLYN FRANZEL

Franzel says, "I was drawn to Alcatraz Island by my curiosity of what it must have been like to have lived there, not necessarily as a prisoner, but as a guard, grounds keeper, or warden; the confinement they must have felt. The Warden's House intrigued me with its empty window looking out to the vastness of the San Francisco Bay and the city beyond . . . What did the warden feel when he gazed out that very window: hope or mere seclusion?"

LINDA HANSON

Linda Hanson is a fine art painter and portrait photographer. Her paintings are in public and private collections in the U.S. and the U.K. She has an M.A. in painting from the San Francisco Art Institute and a B.A. from San Francisco State University.

LEANNE HITCHCOCK

LeAnne Hitchcock received her B.F.A. from the San Francisco Art Institute and a M.A. from New York University and the International Center of Photography. Her images have been exhibited in numerous solo and group exhibitions throughout the United States and in Europe, including at the Friends of Photography, San Francisco, California, and at the Nathan Cummings Foundation and International Center of Photography, New York. Her work resides in the World Studio Foundation, the Calumet Collection, Neiman Marcus Collections, and Musée de la Photographie Belgique, among others. She was the PhotoAlliance coordinator for the Alcatraz workshops.

HENRIK KAM

Henrik Kam was born in Denmark and moved to Los Angeles in 1974 to study photography at Pasadena's Art Center College of Design. He currently resides in San Francisco, and specializes in fine art and architectural photography. His work has been shown in group and solo exhibitions at Blue Sky Gallery, Portland, Oregon; gallery bershad, Somerville Massachusetts; and San Francisco Camerawork, and is in the permanent collections of the Museum of Fine Art, Houston, Texas, and Museet for Fotokunst, Odense, Denmark.

DAN KATZMAN

Dan Katzman is a fine art photographer interested in nature and landscape. His images are often used as prints or architectural panels in large public spaces. Katzman's photography is in the collections of Kaiser Permanente and the National Park Service and has been featured in several books as well as national media.

RICHARD KETTLES

Richard Kettles has studied photography and printmaking at the Academy of Art University in San Francisco.

HUGH LINN

Hugh Linn has been making black-and-white photographs for sixty-five years, using large format 4 x 5 and 5 x 7 cameras. He studied photography at the Academy of Art University, San Francisco, and also at San Francisco City College.

REBECCA MARTINEZ

An award-winning graphic designer for many years, specializing in corporate identification for a variety of prominent corporations and nonprofit organizations, Rebecca Martinez is now a full-time photographer. Her work has been featured in solo and group exhibitions at a variety of institutions, including the San Francisco Museum of Modern Art, Dallas Contemporary, Robert Tat Gallery, Stephen Wirtz Gallery, and the International Photo Festival in Lodz, Poland.

LISA ANN MÜLLERAUH

Lisa Ann Müllerauh is an amateur documentary photographer whose work was included in the 2005 exhibition *Eyes on the Rock: Photographs from Alcatraz Island* at San Francisco's Crissy Field Center. She was assistant photo editor/researcher and contributing photographer for *Street Art San Francisco: Mission Muralismo*, published by Abrams in 2009. She lives in Vermont with her husband, Frank.

ANTON ORLOV

A native of Russia who moved to the United States in 1994, Orlov has a B.F.A. in photography from San Jose State University School of Art and Design. His work has been shown in California at the Santa Clara University Visual Arts Society, and the San Jose Gallery, among others, and featured in the *Madison Review, Photographer's Forum* and San Jose State University's *Reed Magazine.*

ADAM PAPIER

Adam Papier has been working as a large-format printer, Photoshop expert, and photographer since majoring in photography at San Jose State University. Attempting to meld fine art photography with historic interest, he emphasizes form, color, and composition while infusing his images with historical context.

JACKSON KYLE PATTERSON

Jackson Kyle Patterson has been exhibiting his photographs at the Togonon Gallery in San Francisco, the Morris Graves Museum of Art in Eureka, California, and Oregon's Pendleton Art Center since 2000. His work is in various private collections as well as in the Paul Sack Collection at the San Francisco Museum of Modern Art.

ROBERT RENNEKER

Robert Renneker, refers to himself as "a shameless amateur," having become interested in photography just in the last few years. His preference in photography is the casual portrait, capturing people being themselves.

MARK ROH

Mark Roh is a surgeon and amateur photographer. He started to take pictures in 2003, and learned the craft through classes at the Santa Fe Photographic and Maine Media Workshops. He had an exhibition in 2007 at the Silver Eye Center for Photography in Pittsburgh, Pennsylvania, and his work is in several private collections.

DANNI SEMPERE

Danni Sempere is a fifteen-year-old high school student who loves photography and hopes to pursue it as a career.

JAMES SEMPERE

James Sempere is a world traveler, global investment manager, father of four, and lifelong amateur photographer with no publishing, museum, gallery, or display credits beyond his 6th grade art exhibit at the local mall. He says, "Seeing and experiencing the hidden places of Alcatraz, and sleeping the night in cellblock D was a surreal experience—the haunting visual images barely touch the profound sense of isolation and loneliness that I felt on this cold rock."

JASON SHELDRICK

Jason Sheldrick grew up in Ottawa, Canada, and moved to the Bay Area in 2004. Of his Alcatraz images he says, "Growing up rurally, I've been around many older utilitarian structures nearing the end of their lifespans; studying architecture has given me the knowledge of how and why structures are built. Alcatraz is such an interesting place for me because the layers of its past uses and construction are becoming ever more visible."

STEPHEN CRAIG VANCE

Stephen Vance's primary focus is portraiture and architectural photography, employing nineteenth-century processes, including wet-plate collodion image capture and albumen, platinum, and carbon printing. He also collaborates with other photographers, developing custom-made hand-coated silver emulsions on a variety of substrates. Vance serves on the board of directors of San Francisco Camerawork.

MICHAEL VENERA

Michael Venera was born in 1960, in Prague, in what was then Czechoslovakia. After defecting to New York City at the age of nineteen, he made his way across the United States, taking on a variety of odd jobs including fisherman, security guard, janitor, and dishwasher. He attended photography school and, after working as an assistant to a number of photographers, started his own business. He now lives in San Francisco but takes photographs all over the world.

BRIAN WARSHAWSKY

Brian Warshawsky studied photography at the Rhode Island School of Design and M.I.T., and currently lives in San Francisco.

ALICIA WILLIAMS

Alicia Williams grew up in Vermont and currently lives in San Francisco. She is a graduate of the Rocky Mountain School of Photography in Missoula, Montana.

RALPH WILSON

An avid amateur photographer since childhood, Ralph Wilson earns his living in the software industry. He frequently focuses on the urban landscape and the evocative remains of past industrial activity.

University of California Press, one of the most distinguished university presses in the United States, enriches lives around the world by advancing scholarship in the humanities, social sciences, and natural sciences. Its activities are supported by the UC Press Foundation and by philanthropic contributions from individuals and institutions. For more information, visit www.ucpress.edu.

University of California Press
Berkeley and Los Angeles, California

University of California Press, Ltd.
London, England

Produced by HurleyMedia, LLC
Santa Fe, New Mexico

Project management & editorial direction by Joanna Hurley, HurleyMedia, LLC

Design & production by David Skolkin/Skolkin + Chickey, Santa Fe, NM

ISBN 978-0-520-26082-5 (cloth)
ISBN 978-0-520-26084-9 (paper)

Library of Congress Control Number: 2010934389
Printed and bound in Singapore by Tien Wah Press

19 18 17 16 15 14 13 12 11
10 9 8 7 6 5 4 3 2 1

The paper used in this publication meets the minimum requirements of ANSI/NISO Z 39.48-1992 (R 1997) (Permanence of Paper).